Dedicated to my son Herbert, my favorite little
Light Being who was born on September 13, 1989.

The photographs in this book have been converted from color to black &
white due to printing concerns. Readers can access the original full color
photographs by Dorothy Wilkinson-Izatt at the following web site.
Timeless Voyager Press will continue to update this page in order that
researchers and interested parties have complete access to Dorothy's
work.

http://www.timelessvoyager.com/cwbol.htm

CONTACT WITH BEINGS OF LIGHT

TIMELESS VOYAGER PRESS
PO Box 6678
Santa Barbara, CA 93160
1-800-576-8463

Covers and book development by Bruce Stephen Holms

Photographs from Dorothy Wilkinson-Izatt

Photographic Editing by Bruce Stephen Holms

Artwork by Lucy West

Contact With

BEINGS

OF

LIGHT

The Amazing True Story of

Dorothy Wilkinson-Izatt

Peter Guttilla

Formatting and Development by

Bruce Stephen Holms

Editing by Linda White

TABLE OF CONTENTS

Part Two

ACKNOWLEDGMENTS

With respect and thanks to:

Dr. Lee Pulos, Dr. Du Fay Der, and the many friends of the Izatt family.

The memories of Duncan Izatt, Elaine Alexander, and Dr. J. Allen Hynek.

The professionals, critical readers, and loving friends who gave their utmost support and approval of the manuscript throughout its development.

Dorothy Izatt for granting me the privilege of writing a concise biographical account of an important period in her extraordinary life.

Part One

New Worlds for Old

First Contact

Thursday, November 9, 1974 was an exceptionally mild Canadian autumn day. The land was alive with sounds and colors, the reds and the yellows and auburns, the shouts of children playing in a nearby soccer field, the shrill cries of birds gliding across the sky and settling into the green-gold of the trees.

Dorothy Wilkinson-Izatt stood at her living room window and watched the clouds move slowly toward the horizon. It was almost four o'clock in the afternoon and time for the "quiet hour" she routinely set aside for prayer. Daily devotion was her custom, her way of giving thanks for having been blessed with four healthy and happy children, her devoted husband, Duncan, and a good life in the little town of Richmond, B.C., a suburb of Vancouver. She found it hard to imagine that nearly twenty years had passed since she and her family moved from faraway Hong Kong to Canada. But it had indeed been nearly two decades, and the thought brought mixed feelings of gratitude and sadness. Yet she had no complaints, and as usual her ambivalence was quickly replaced by a keen sense of satisfaction. She was, after all, a woman of naturally high spirits and, despite her occasional reveries into the past, she remained so.

With a sigh Dorothy left the window, lit a small candle on a nearby bureau, and knelt quietly in meditation. "But this time it was different," she recalled later. "While I was quieting my mind, I had a most beautiful sensation. It's hard to describe. It was something I'd never known before, like a great

upsurge of love and happiness." Silently, she lingered in the exhilaration of the experience until it ebbed slowly and was gone.

Dorothy stood, straightened her shoulders, and suddenly felt bewildered. Now she had the strangest feeling she was being watched. She walked across the room and peered out the window and drew a quick, involuntary breath. There, bright and crystalline, suspended in the middle of a clear patch of sky, was a beautiful spinning object that looked like a huge diamond with a horizontal ring of lights revolving around the middle. As she put it, "The object was magnificent and brilliantly lit by lights with a rotating disk of light at the base. I couldn't believe what I was seeing."

Momentarily doubting her senses, she turned away and shut her eyes, then looked back. The sparkling object was no illusion; it was definitely there, dazzling and crisp and seemingly alive. In her journal Dorothy wrote, "Then, as if it had read my doubtful thoughts, the crystal-like object began to dart in and out of clouds, and I instantly had the impression it was giving me further proof it was real. It really was quite wonderful to look at."

Dorothy was powerfully captivated by the warm brilliance of the UFO. There was something in it, or coming from it, that evoked feelings of elation, optimism, and expectation in her. But the incident was also puzzling, and more so when both the sensations and the object disappeared abruptly. The sudden emptiness left her slightly confused, but calm, almost to the point of indifference. "It was odd," she said, "I didn't feel any emotion about it. I just turned from the window and went on with my chores as if the object had come and gone, and that was the end of it." Dorothy didn't realize that her earlier feelings of blithe "expectation" were portents of things to come. The unexpected adventure was far from over.

That night after dinner she and her husband sat watching television. Duncan, a professional electrical engineer, was tired from a long day at his job with B.C. Hydro and wanted nothing more than to sit still and watch his favorite hockey game. "It was almost seven o'clock," Dorothy remembered, "when an intense beam of light pierced the living room drapes and shone directly on me." Duncan hadn t noticed anything because "he loved sports and you couldn't get him to take his eyes off the TV, but she definitely saw the white beam shining in from somewhere outside. It was intense, too, and powerful enough to penetrate the heavy fabric of the drapes. Dorothy glanced at Duncan, who was still absorbed in his hockey game. She got up quietly, opened the drapes, and was half-surprised to see an enormous, stationary ball of light in the sky, low on the horizon.

The glowing ball was different from the spinning wheel she had seen earlier - of this she was certain. Flashing brightly, it hovered, then started to wobble from side to side. When it did this, Dorothy became aware of something, something mental. "Communication," she thought, "like it was touching and searching my mind. I know I heard the words, 'We are real; we are here; it is not your imagination.'"

Despite the reassuring words of the eerie message, Dorothy was suspicious. Was this really something otherworldly? Was it communication or merely a trick of the mind? She decided to test herself and the mysterious light source together in one move. She got a flashlight and returned to the window. After a few seconds of staring at the object, she said mentally, "If you can hear me, please repeat what I'm going to do with my light." She blinked the flashlight three times to the right and three times to the left. The object responded with three blinks to its right and three to its left. She repeated the test, but this time she flashed the light above and below. The object answered in kind. Finally, Dorothy "zigzagged" the beam of the flashlight and the ball of light zigzagged from side to side.

Following the initial exchange with Dorothy's flashlight, the glowing ball took on a life of its own; it danced, pulsated, and maneuvered sharply back-and-forth. This action and interaction gave Dorothy pause. Was she letting her imagination get the best of her, or was this the beginning of a new relationship with the unknown? She tried to reason with herself, to find some compromise between fantasy and fact, but she could not deny what she was seeing. The object, the UFO, the thing in the sky was anything but imaginary because it moved and responded intelligently. It was real - it had to be - and the implication ignited her curiosity.

Deeply fascinated, but aware that she could end up spending hours at the window, Dorothy decided to take a break and return to some semblance of normalcy. She did not want to disturb her husband who was perfectly content to stay with the hockey game, so she washed the dinner dishes and finished other chores. An hour later she went back to the window to see if "they" were still there but the sky was dark, which for Dorothy was both a disappointment and a relief. Two strange events in one day had been exciting but emotionally taxing, and she needed time to gather her feelings. Mercifully, the rest of the evening passed without incident.

The following night the light returned. Dorothy again tried the flashlight test with assorted variations, and the enigmatic ball of light responded with precision to each pattern. Now the question was whether or not to tell her husband about the experience. Duncan was always gentle and never ridiculed

her, but he was painfully disinterested in UFOs and not the kind of man to get excited about much of anything, let alone a mere blob of light in the sky. Of course she would tell him anyway - they kept no secrets from each other - but she wasn't going to make an issue of it or bring up the "communication. Seeing a UFO was one thing, but talking to one was something else entirely and, as she later described it, that would certainly have convinced Duncan I was approaching my dotage."

The third night was a replay of the previous two, except Dorothy's oldest son, Wayne, came to visit. Duncan was alone in the living room glued to another of his beloved hockey games. Wayne walked in and stood next to his father's chair.

"Where's mom?" he asked, touching his dad lightly on the shoulder.

Duncan didn't look up, "She's probably in the quest room watching that light in the sky again."

Wayne went to the guest room and found himself in total darkness. His mother was little more than a shape near the window.

"What are you doing in the dark, mom?"

"Watching the light up there," she said. "It moves, you know."

Wayne looked out the window and easily spotted the object halfway between the zenith and the southern horizon. "Could be anything," he said with an air of confidence. "If you look at a star long enough, it'll appear to move."

When Dorothy pointed out that the light was moving much too enthusiastically to be the product of eye fatigue, Wayne decided to go out to his car for a pair of binoculars. He returned in a few minutes, handed the glasses to her and left, preferring to watch the hockey game with his dad. Wayne's attitude annoyed Dorothy, but she had learned to live with her husband's lenient skepticism, and there was no reason to create a fuss over it with her son.

She raised and focused the binoculars on the glowing ball and was astonished by the magnificent light show that ensued. A stream of small, round, sparkling lights jetted out from the larger one, circled, and disappeared behind it.

Without lowering the binoculars, Dorothy mentally asked, "Could you please send them around again?" As if on cue the lights appeared, this time circling the larger light in a V-formation.

"That was wonderful," she said with her thoughts. "Will you do it one more time?" In response, the miniature lights emerged again but now in random groups. They circled and reentered the larger light which, seconds later, vanished in a quick, blue-white flash. Dorothy watched the sky for a little longer, but the activity had stopped, at least temporarily.

That morning at four o'clock she was roused from a sound sleep by a "warm" beam of light and was again drawn to the window. Duncan stirred but didn't waken, and she thought better of disturbing him. Outside, the beautiful bright ball was back, but much closer than before; so close, in fact, that it made the tops of tall trees sway from side to side in the otherwise windless morning air.

The ball hovered, showing no signs of movement until, in a bright burst, one by one, lights of various sizes and shapes poured from it in massive numbers. Even though the explosion of activity alarmed Dorothy, the feeling quickly subsided. Her curiosity was overwhelming and she was determined to watch more of the display. Duncan stirred fitfully in the bed, turning and shifting as if he were trying to waken but couldn't. Probably it was better that he didn t wake up, given that his doubting nature might somehow interfere. She was thinking this - but she had never thought of it in that way before, and she wasn't sure if the idea was hers or if it had come from somewhere else; whatever its source, it made sense.

At that moment, Dorothy heard or felt the words, "Don't be afraid." The message was followed by mental images of lighted "probes" gliding wraith-like through physical obstacles, scanning the earth, listening, watching, gathering detailed information of earth-life in billions of luminous memories; sorting, storing, and soaking in all the natural and manmade events of human history. All of this came and was gone in seconds. Dorothy brought her hands to her face. The onslaught was overpowering; she had no idea what any of this meant, or where the images came from, and it drained her emotionally. She took a deep breath, stepped back from the window, and leaned against the bedroom wall. Closing her eyes, she stood for a minute and was suddenly overcome by a deep, palpable calm. She turned slowly to her right and looked up. Just outside the window a small white light appeared, passed through the glass, and glided toward her. It stopped at eye level, hovered momentarily, then "danced" and darted around the room. Strange and utterly silent, the little elf-light was quite bright but cast no glare and produced no shadows. Moving in a smooth, fluid motion toward the bookcase, it "hopped" from book to book before leaving through the window in the direc-

tion of the bigger, hovering light above the trees. Dorothy glanced at the bookcase, wondering if "they" were scanning her books. She tried to rouse Duncan, but he was sleeping soundly, and she gave up after a few ineffective nudges.

Then, as the large light continued to hover, in full command of its place in the sky, Dorothy had a sudden attack of anxiety. The change was disorienting and in sharp contrast to her feelings of just minutes earlier. For some reason - which she later attributed to an instinctive "flight or fight" reflex - it occurred to her that she might be watching the onset of an invasion! She hurried to the phone and called the tower at the Richmond airport and, out of shyness or embarrassment, she reported her sightings in minimum detail. She asked if they had received any UFO reports, presuming they must have gotten dozens, considering the intensity of the display so close to a populated area. The airport's spokesman was polite but patronizing, his tone implying she was either drunk or deluded. . .or both. "We've had no reports of any UFOs in the skies above Richmond," he said in a flat voice.

Puzzled by the response, Dorothy went back to see if the lights were still there, but the sky was empty and beginning to show signs of daybreak. Duncan woke up and lingered in bed briefly, apparently none the worse for a night of tossing and turning. She tried to tell him about the lights, to coax his interest, but his response was less than enthusiastic - he nodded and gave a somewhat exasperated sigh — and she finally decided to drop the subject.

Dorothy tended to her husband good-naturedly that morning, but not too many words passed between them. She loved him very much and she knew he was a good man, but she was also aware that he was stubbornly attached to his own concepts of reality and now, for the first time in twenty-five years of marriage, she felt alone. Intuitively, she realized that it was an essential prologue to the way it was going to be from then on; not only with Duncan, but with her children as well. Yet Dorothy found strength in herself. What she had seen was real and no one - nothing - neither material ties nor parental bonds were going to convince her otherwise.

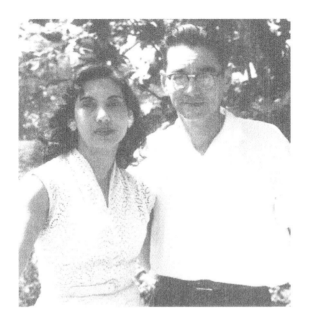

Dorothy and Duncan

A Voice From Beyond

When Duncan left for work, Dorothy puttered around the house, finding things to do. After several hours of routine chores mingled with repeatedly unsuccessful attempts to resist thinking about the lights, she decided to phone The Province News in Vancouver. Once again the attitude was curt and cynical. There had been no UFO sightings reported from anywhere in the vicinity, as far as they knew.

In the absence of corroboration, Dorothy was caught up in her own frustration. There should have been widespread reaction and yet, apparently, there was none. How this could be? If it were an invasion, there would be no defense against such superior technology anyway, and why Richmond of all places? Why not Washington or London or some other important world capital? It was lukewarm comfort, but after a good deal of self-talk she realized her fears were exaggerated. Besides, she had experienced a sense of "friendliness," or perhaps even "love," and not once had she felt threatened. What kind of invasion was that? Maybe their plan was to destroy the world with kindness? Dorothy shook her head in mock disbelief and went on with the day's activities, somewhat relieved but no less mystified by what had happened.

The rest of the day thoughts about the UFOs crowded everything else out of Dorothy's mind. With an effort, she pushed herself into busy-work and did so until nightfall. At nine o clock, the visitors were back. This time dozens of small, luminous diamonds hovered, wriggled, and played in the sky as

Dorothy again watched at the bedroom window. From the outset she was bathed in a feeling of warmth, which was both physical and visceral; the vague fears and pressures faded amid the glowing splendor of the lights. Unable to resist the temptation, she asked aloud, "What are you doing here? What do you want?" There was a brief shimmer of amethyst-colored light and the utterance, "We are observing, we see, we hear. Dorothy heard the words in her mind, but they seemed to be audible as well, and she remembered wondering how it was that they "spoke" English? The response was instant and to the point, "No language is necessary. We speak through the mind."

Clearly, a deliberate and equal communication was taking place. There was nothing tentative or ambiguous in the exchange, and Dorothy realized the significance of what had occurred. She had never thought of herself as "telepathic," but the words of the visitors were distinct. It was as if she had been talking to somebody standing next to her in the room. This was far more than a minor revelation because it implied the visitors could communicate directly with the mind, which carried the further implication of an utter lack of privacy. Deception was a way of life for human beings, taught from the cradle to the grave to mask their true feelings, to never reveal too much about themselves. Could the visitors detect secret thoughts, attitudes, emotional states, and perhaps character? Dorothy asked this question and the answer was, as she wrote later, expectedly consistent: They told me that just to look at people, to invade their privacy, was not their purpose and was of no interest to them. They're not extraterrestrial Peeping Toms. They've been watching the planet for eons and are well aware of the way people behave, which they find appalling. Their purpose was, and is, to focus on the direction and eventual evolution of mankind."

Dorothy also asked, "Why me? What do you want of me?"

"They said they 'knew' me from long ago and were familiar with the kind of person I am...it's a person's total being and character that determines whether a communication takes place. If the right qualities aren't there, people won't see them, or if they do, they'll be terrified of them or try to explain them in some way that fits their own beliefs...all this is determined by the state of the person who's observing them.

Now, Dorothy understood why there was no reaction by the immediate outside world and why members of her own family refused to acknowledge, or consider seriously what had been happening. It was not that they deliberately avoided sharing in her experience they were compelled not to, partly

due to the presence or absence of certain qualities of mind and character, and partly due to the will of the visitors.

Dorothy watched the lights for several hours that night, then slept well for the first time in many days. The communication had given her a sense of well-being that would always be difficult to explain. She just "knew ; it was that simple. She knew the visitors meant no harm, that they were "intelligent, benevolent beings from many places in the universe," and knowing this comforted her. Outsiders could only speculate, analyze, and wonder, and this division between her understanding and the puzzlement of those around her would continue in varying degrees from then on.

Dorothy Izatt's nightly encounters with the visitors continued unabated for several weeks. Each time they came, something new was learned - it was, in her words, an "enlightenment of immense grandeur and depth. It was all so beautiful.

But there was an unforeseen backlash. Between periods of contact, Dorothy discussed her experiences with others and that was, as it turned out, a serious mistake. Well-intentioned friends, mostly those of strong religious convictions, felt obliged to warn her about "demons" and "evil" and the potential for sinister motives behind the outwardly benign behavior of the visitors. "At first I didn't pay much attention to those comments from other people," she said, "but it must've got to me because thoughts of demons and evil-doings began to torment me and interrupt my communications with the lights...I know they sensed my doubt and anxiety.

Dorothy realized that once fear and hostility, or doubt, weakened the rapport, the communication was degraded. It was clear to her that the "Light Beings" - as she would come to call them - were aware of the change because the overall vitality of the communications diminished as though the bond had been suddenly breached. At the same time, apparitions or "lower-order beings," whose nature and affect were intensely uncomfortable, showed up. Dorothy could not identify the intruders or "presences but frequently felt their emanations, occasionally glimpsing coal-black, indistinct shapes that exhibited a distinct aversion to light. She was never given to thinking about ghosts or phantasms, but the presences were definitely ghost-like, preferring darkness and always "scurrying" into the shadows whenever she turned on the house lights. Dorothy quickly pieced together the connection between light aversion and the nature of the negativity she had allowed to enter her mind. "Lower forces hate light," she was told by the Light Beings, and it occurred to her that those who sought to infect her with fear were themselves being influenced by the lower forces. It was an unpleasant thought and a

dismal commentary on the human condition. She had to free herself from the destructive sway of the people around her, even those who claimed to have her best interests at heart.

About this conflict between "good and evil" and its effect on what was beginning to take place in her life, Dorothy wrote the following in her daily journal: "Today I was feeling quite down because nobody would believe me or accept my feelings that what was happening is good and beneficial. Some of my friends worry that I'm giving myself over to devils. My husband thinks I have an overactive imagination, and my children think I'm going through an awful 'crisis.' They whisper behind my back to my husband, wondering what they can do for poor old mom. There has been constant pressure on me, and I have felt my nerves going bad because of the teasing, the doubts, and the fears of my family, in-laws, and friends. I didn't think I could take anymore, and I went into the guest room with tears in my eyes, feeling desperately alone. My little granddaughter, who is only seven years old, came into the room, pulled up a chair by the window where I was standing, put her arms around my neck and said, 'Nevermind, grandma; if no one else believes you, I do.' She kissed me on the cheek, and I'll never forget that beautiful gesture as long as I live. I shall always treasure it. I realized that what I'd been losing gradually was a child-like, open heart and mind. My Light Beings are loving and helpful and real, and I know if I want to stay in contact with them, I have to recapture a child's innocence.

It did not take long for Dorothy to grasp what was happening. She summed it up thus: "We are where we dwell. When we live in a state of fear, dread, suspicion, that's what we receive...it's really just that simple."

With a conscious effort, Dorothy was able to rid herself of the encroaching negativity. The "presences" vanished, and eventually a high level of communication was re-established. It was a bitter lesson, but the guiding principle of "positive mind, innocent heart" became her newly acquired rule-of-thumb and her general recommendation to others, particularly if they wanted to share in her experiences, either directly or indirectly.

In the ensuing weeks, night after night, the benevolent lights returned with increasing vigor. There was a parallel inward change in Dorothy, one that was hard to define but dynamic nonetheless, and a major turning point was reached on a cold mid-December morning in 1974. Just before dawn, Dorothy awoke to a beam of light that looked light an incredibly beautiful amethyst mist. At the leading edge of the diffuse beam a soft, compassionate "eye" took shape, and from it a narrow column of light emerged and entered Dorothy's left eye. She felt no fear, no anxiety, no discomfort - rather, the

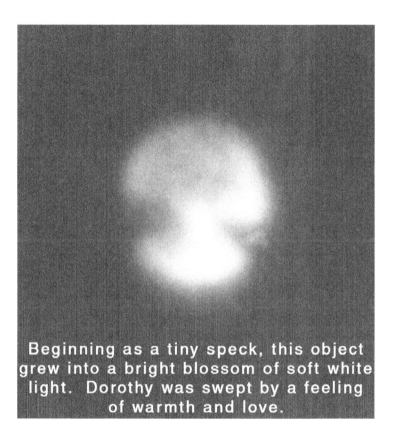

Beginning as a tiny speck, this object grew into a bright blossom of soft white light. Dorothy was swept by a feeling of warmth and love.

action was sublime and uplifting, and she knew it was an important part of a conditioning or purifying process intended to accelerate her understanding. This event differed from the others in that there was a definite "mystical" feel to it...something spiritual in its implication. She wrote: "I knew then more than ever that all this was from God, that my Light Beings were, in truth, angelic in nature, perhaps angels themselves, or of such a high order of life as to be angelic. My mind reeled from the beautiful amethyst light, and I felt myself being raised. I knew I was being conditioned or prepared in some way to perceive things differently...things like energy, life, space and time, and the actual existence of dimensions of life unknown to me.

The episode ended almost as quickly as it had started, and for a while Dorothy lay suspended between this world and somewhere "out there." She remembered thinking, "If only I had proof of all this, some way to share my experiences with others, some way that nobody can deny or say that I am dreaming or imagining things.

From elsewhere an answer came: "We will give you proof." Dorothy heard, nodded, and smiled.

Her last journal entry on that day reads: "By chance today I happened to hear Pat Burns (a prominent local radio personality) on the air talking about UFOs, and I decided to get in touch with him. When I tried, I was instead referred to his producer, Elaine Alexander, and we had a lengthy conversation about my sightings and experiences. She said no one would believe me unless I had pictures to prove it, so I borrowed my husband's 8mm movie camera.

What was to follow would profoundly affect Dorothy Izatt's life and the lives of untold numbers of people throughout the world for many years to come.

Proof On Film

Two days after her conversation with Elaine Alexander, Dorothy decided to film the visitors. At 7:30 p.m. on the night of December 14, 1974, she borrowed her husband's Super-8mm movie camera and went to the darkened guest room. A thin, gray coating of starlight from the window spread across the floor...

"I just stood there in the dark, waiting. I was anxious because sometimes the objects were there and sometimes they weren't, and I really wanted to prove that I wasn't imagining these things. I sent the thought that I was there, and while I waited I began to feel afraid that they might not show up.

Sighing, Dorothy sank back, her vitality drained by the monotony of staring into a black sky. For the first time she was initiating contact with the Light Beings. The situation was reversed and she felt she had to reach out in an intense effort to connect to unknown something in an unknown somewhere, and the urgency of it, the exertion of trying to project herself outward, almost made her cry. What if they didn't come back? She tried to imagine what it would be like to live with an experience that she couldn't prove to anybody else. It was an awful prospect.

Then, as if in response to her distress, a huge golden ball appeared, surrounded by a ring that emitted specks of bright red light. Its quick appearance and breathtaking beauty stunned Dorothy momentarily, and for an instant she could nothing but stand and watch.

With an effort she regained her composure and, concerned that even a pane of glass might impede the communication, she threw open the window and mentally asked permission to film. She pointed at the object, then to her camera, then at the object again, nodding her head. The golden ball began to pulsate which she translated as a "yes."

Hands trembling, Dorothy raised the camera and began filming as the object pulsed, danced, and maneuvered perfectly, never moving far from the camera's narrow field of view. Her elation was tempered only by her concern that she wasn t operating the camera correctly. It was, after all, the first time she d ever even held one.

Soon thereafter, the fiery ball of light vanished as suddenly as it had arrived. Dorothy, exhausted, fell into a chair, clutching the camera. The little box of plastic and glass held light from another world and to her it was more valuable than a precious gem.

Late the next night the sky seemed to shudder, as a dozen icy lights flashed and leaped back and forth like animate diamonds on black velvet. Dorothy filmed again, but this time there were intermittent bursts of intense brilliance that seemed to punctuate various maneuvers. The activity went on for more than an hour and when the last few frames played out, she hoped she had more than enough to make her case.

The following morning Dorothy sent the film to the developer and checked the mailbox anxiously for the next several days. When the package finally came, she hurriedly set up her movie projector but was quickly disappointed. In her haste to film the lights she had failed to adjust the focus or to use the zoom lens. The results were fuzzy, unsteady bits of light that barely resembled the beautiful objects she had watched through the viewfinder.

Elaine Alexander, on the other hand, was thrilled. "At least you're getting something," she said emphatically. "It proves you aren't imagining these things. Don't give up.

The lights appeared nearly every night for over six weeks, giving Dorothy ample opportunity to perfect her skill with the camera. However, in the interim she had had to exchange her aging movie projector for an upgraded model that could be slowed and paused without burning holes in the film — two rolls had already been destroyed. Having still photographs made from 8mm movie film also proved to be a problem. To provide individual frames for processing, Dorothy laboriously snipped out the tiny squares with scissors and spliced the remaining film together haphazardly.

"It was all very frustrating," she said later. "There I was, a housewife and mother with no experience at such things, and not only did I have to learn how to use the camera, I had to struggle with everything else. I didn't know anything about projectors or getting photographs made from movie film, so I did the best I could. I had no one to help me and, except for Elaine's encouragement, I might have given up.

Elaine Alexander

The Scientists

Near the end of February 1975, two months after her initial attempt at film-
ing and now armed with five reels of proof, Dorothy felt she had sufficient
evidence to challenge the skeptics. Elaine Alexander was so impressed that
she contacted J. Allen Hynek, astronomer and leading UFO authority, whose
book, The UFO Experience, a Scientific Inquiry, had already become a sta-
ple among UFO enthusiasts throughout the world. Dr. Hynek had been an
astronomical consultant to the US Air Force's Project Blue Book in the
1950s, and in 1975 he was director of the Lindheimer Astronomical
Research Center at Northwestern University in Evanston, Illinois. Elaine
had met him when he appeared on Pat Burns radio show the year before and
was familiar with the famous scientist's credentials and, perhaps most impor-
tant, his considerable influence within the scientific establishment. Follow-
ing her enthusiastic description of Dorothy's filming episodes, Hynek agreed
to meet with the two of them at Elaine's home in Vancouver during the sec-
ond week of March.

Three weeks later Dr. Hynek, Dorothy, her husband Duncan, and Elaine
Alexander sat together in cordial silence as Dorothy nervously switched on
the projector. Interest showed in Hynek's expression at the first flash of light
on the screen; brows crinkled, he leaned forward in his chair and sat in rapt
attention, shifting his eyes occasionally to Dorothy as she described the con-
ditions surrounding her experiences and the events of prior months. Dor-
othy, looking for a reaction, glanced frequently at Hynek. Each time he

turned his head, the squiggling lights reflected in his eyeglasses and it made her smile. It was satisfying - if strangely surreal - to see the face of a noted scientist wax luminous from the otherworldly light that had consumed so much of her personal life.

When it was over, there was an interval of pensive silence. Then Hynek, a thin, soft-spoken man, stood from his chair. "Dorothy, does the camera you've been using have more than one speed?"

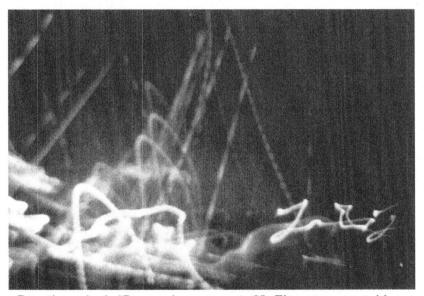

Dorothy asked, "Do you have a name?" There was a sudden flash of light and the object was gone. The developed film showed an explosion of movement with what appears to be a "signature in light" bottom right.

"No, just one speed. It's super-eight. Not very fancy at all. Any child can operate it."

Hynek smiled genially. "Of course I can't be sure without studying the film more closely, but the lights appear to change position instantly. I suspect this happens within each frame. Can you account for this?"

"No, I can't. It's a mystery to me. I can't slow down the film speed or make it go faster. I can sometimes see the lights move, but never as fast as they move on the film."

"A fixed film speed...that's important," Hynek said, skimming over a dozen photographs Dorothy had spread on the coffee table. "The film is moving at eighteen frames per second, which means the lights move considerable distances in one-eighteenth of a second or less."

Dorothy nodded her head. "Yes, it all happens in the blink of an eye. Sometimes it feels as though they're coming right at me. When there's a flash, I sometimes know they've moved very rapidly in my direction...I can feel it.

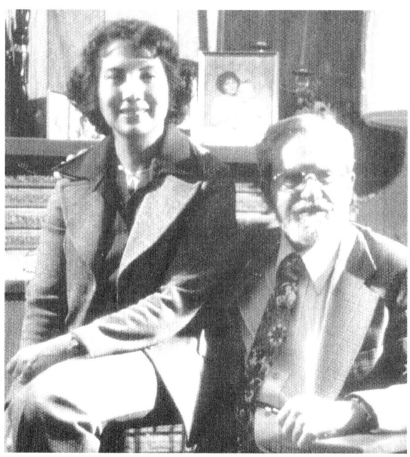

Dorothy with Dr. J. Allen Hynek in 1975.

"By 'feel' do you mean a physical sensation?"

"It's hard to explain. It started when I first saw them and even more so after I picked up my camera and started filming with it. Sometimes something happens like some sort of energy transference. I don't know how they do it. It's all so quick, so fast...of course sometimes the light's so bright it hurts my eyes a little.

"Do you believe you're in communication with the lights?"

"Oh, dear...I suppose," Dorothy hesitated, not sure of how her answer would settle in the mind of practical scientist. "Well, yes...I think so because I do know when they're there. I sometimes see a flash of light inside the house, and at other times I just sense them and I start filming. When you see those bright white flashes on the films, I think that's when they're sending me something or sort of talking to me.

Hynek looked at Dorothy for a long, thoughtful moment. "Well, clearly you have something of potential scientific value here, but I must admit at the moment I'm hard-pressed to suggest an explanation. These are obviously lights in the sky. They do not appear to identifiable sources. Why so many so often, particularly to the favor of a single observer, is the question. And yet two important conditions have been met. A reliable witness, and genuine photographic evidence of what was seen. It should be pursued.

Despite his uncertainty about the nature of Dorothy's nighttime lights, Dr. Hynek was vigorously supportive. He urged her to use a tripod instead of handholding the camera, and not to tamper with the film in any way - no cutting and splicing - and to keep accurate documentation.

Before he left, Hynek warmly reassured Dorothy: "You've got something here, stay with your work, it's unique. Keep me informed of your progress...I'll do what I can to help."

The opinion of a respected scientist lightened Duncan's mood with regard to his wife's peculiar "hobby," and Elaine Alexander was visibly elated by the outcome of the meeting. For Dorothy, Dr. Hynek's reaction bolstered her confidence, and throughout the next seven months she followed his advice to the letter, producing nearly two dozen reels of film filled with clear and steady images.

By the fall of 1975 local enthusiasts were awash in rumors of Dorothy's extraordinary photography. In October, through the offices of the Vancouver Psychic Society, a clinical psychologist named Lee Pulos contacted Dorothy and arranged for a meeting.

Describing the moment, Dorothy said, "Dr. Pulos heard about my films, and he and his wife came to see me. I could tell he was somewhat skeptical, but he seemed very open-minded and interested. His opinion was very much like Dr. Hynek's. He had no explanation for the lights, but he felt there was definitely something to it. Of course, it's what happened later that evening, and again on his second visit, that impressed him all the more.

What "happened later that evening" happened while Dorothy, Dr. Pulos, and his wife stood talking near a large living room window. A bright light in the night sky caught Mrs. Pulos' attention. "Is that one of the lights?" she exclaimed, pointing over Dorothy's shoulder.

Dorothy turned to the window and instantly recognized the familiar blue-white quality of the light. "Yes, I think it is." She got her binoculars from another room and handed them to Mrs. Pulos. "Take a look," she said, confidently.

Mrs. Pulos peered through the glasses and after an anxious moment cried out, "It is! It's disk-shaped! It seems to be getting brighter. She handed the binoculars to her husband who watched the shimmering light for several minutes as it moved from side to side like a pendulum.

"It's definitely not an airplane," he said in quiet, drawn out voice. "It doesn't appear to be a star...or planet...and it is disk-shaped.

Dr. Pulos watched the object for several minutes, and by his expression it seemed as if a cold chill had washed over him. Dorothy understood only too well; she knew it was the result of being confronted suddenly with a new reality. But it was probably his next visit with Dorothy a few weeks later that had the most profound affect on Dr. Pulos:

"At Dorothy's invitation, a friend and I went to visit her, and we saw a cluster of stationary lights in the sky. I couldn't believe it. When I told Dorothy that the lights were obscured by a tree, she said she would ask them to move for me. Of course my immediate reaction was that of the practical scientist - yeah, sure, no way, I thought to myself. But as I tracked them with my binoculars, they actually began to move. When they moved into clear view, I asked Dorothy if she could ask them to stop. She did this, and they stopped. Then I asked her to have them move back again to their original position because I couldn't believe what I was seeing. At her request the lights moved back to their earlier position. And this was no hallucination; we all saw it happen. I had no remaining doubt that what she was experiencing was real.

Lee Pulos was to become one of Dorothy's staunchest supporters. Over the next year he visited her regularly - sometimes alone, sometimes in the company of groups from various universities. As the word spread, a battery of investigators and researchers of all types and inclinations descended on Dorothy. Several came from Simon Fraser University, the Universities of Victoria and Saskatoon, Sante Fe University, and the University of Chicago. Scientists, professors, philosophers, psychics, students, UFO buffs, and the merely curious paraded through the Izatt s living room. "My friends didn't know what to think," said Dorothy, "and my poor husband, what he had to put up with. When he saw that all of the people were polite and genuinely interested in me, he just patiently stood in the background and watched it all.

Predictably, the crowd of zealots, after ruling out aircraft, ordinary natural phenomena, weather balloons, poltergeists, phantoms, Indian spirits, motes in the eye, dust on the camera lens, and assorted versions of these types of explanations, could not explain the photography and wound up focusing their attention on the photographer in their search for alternative explanations. They dutifully interrogated, examined, and tested Dorothy, only to walk away equally perplexed.

About that period of time, Dorothy wrote: "Each week I received dozens of calls and letters and had many visits from UFO clubs, psychic and spiritual groups, and a lot of people from local universities here in Canada. They all seemed completely puzzled by the lights, so most of them then wanted to concentrate on me. One university group asked me to stare at batteries set in ice and describe what I saw. I saw energy, which evidently was right. Then they turned off all the lights, put some aluminum plates on the table, and asked me what I saw. I said I could see light coming from the plates, and that seemed to please them. Another time one professor came with a group of students. Their interest was parapsychology, and a man with them brought equipment for Kirlian photography of me. I had little or no knowledge of any of those things, although I did find it interesting. Even though these people were interested in the lights and my films, their attention turned to me and whether there was something different about my eyesight, or if I had any psychic ability. Most of them told me they felt I had unusually high psychic ability, especially visually.

Apparently they were right. Verification of Dorothy's unusual visual acuity came quite accidentally when she discovered she could actually "see" microwaves. "It happened while heating a cup of chocolate in the microwave oven for Duncan," she said. "I was watching the cup to make sure it didn't

boil over, and I could see the microwaves coming down. It was pretty, they were coming from two sides and crisscrossing each other where they came down in the center."

Dorothy brought the cup to Duncan. "I didn't realize how pretty microwaves are to watch," she said with quiet assurance.

"What do you mean?"

"The microwaves...in the oven...they're very pretty.

Duncan looked at her incredulously. "Dorothy, you can't see microwaves, that's impossible."

"Oh yes I can," Dorothy replied, "I was just watching them!" She gestured and explained how they crossed above the cup.

Duncan leaned his head back against the chair and looked at the ceiling. "All right, if you say you saw microwaves, you saw microwaves."

"I guess it does sound strange," Dorothy said, trailing her words as she left the room, "but I really did see them."

The next day Dorothy mentioned the incident to several people, and each had the same comment: "Microwaves aren't visible to the human eye!" It wasn't until several weeks later that confirmation came in a roundabout way.

"I was heating water in the oven and saw the microwaves again. This time I noticed that some of them were shooting out of the left side of the oven and were striking the refrigerator opposite. That alarmed me.

Dorothy phoned the appliance outlet where she had bought the oven, and a repairman was sent. He checked the oven for leaks and after a time said, "I don't find anything wrong here."

"I told him to check again," Dorothy recalled. "He gave me an odd look, but he checked it again and, sure enough, it was leaking. He asked me how I knew, and I didn't want to tell him because I felt stupid about it. I just told him I noticed that he'd missed a part in his inspection. He said the leak wasn't at a dangerous level, thank goodness."

The clincher came when a group of local enthusiasts met with Dorothy several weeks later. One of them, an engineer, listened to Dorothy's microwaves story and then examined the oven himself. He read its serial numbers and asked her to explain what the microwaves looked like. Dorothy obliged and the man smiled, "That's exactly right," he said, "I designed this model."

"It was sweet revenge," Dorothy remembered. "Duncan heard what the engineer said and after that he never doubted me; neither did anybody else. Personally, I never questioned what I saw. As I think back, it must've been because I didn't know that people weren't supposed to see microwaves!"

In January 1976, on his way back to Illinois after a business trip to Vancouver, Dr. Hynek met with Dorothy again. It had been nearly a year since their first meeting, and he was pleased with the quality of the films. This time he left with several samples for analysis and on May 5th sent the following letter from his offices at Northwestern University:

Dear Dorothy,

I have now made a study of the films I brought back with me. The pictures remain very puzzling, not only for me, but to our photographic expert, Mr. Fred Beckman. There is one possibility that must be ruled out before we can make any definite decisions about the photography. In some cameras the film will momentarily stick on one frame with the shutter open and then hand motion will cause very interesting patterns. I have done this deliberately with theater lights, keeping the shutter open for several seconds, and have obtained patterns resembling yours. I do not think this is the case here, but it must be completely ruled out.

This can be done by employing a second, completely independent camera, and if the same thing occurs again, then it rules out a faulty camera.

If this possible cause is ruled out, then Mr. Beckman and I are quite willing to take this on as a research problem. Mr. Beckman has raised another point. Is it necessary to always take these pictures from the same window? Now that the weather is good, could these photos be taken outdoors with no obstruction whatever in front of the camera?

Rest assured that both Mr. Beckman and I are seriously interested in this "Izatt Phenomenon."

Sincerely,

J. Allen Hynek

On Dr. Hynek's suggestion, Dorothy decided to try filming the objects with a different camera and to see if the same objects could be filmed simultaneously by someone else using her camera - both without tripods.

One evening while Elaine Alexander's daughter, Leslie, and a friend sat talking with Duncan, Dorothy and Elaine set to work on their experiment. Dorothy took up her son's camera, which was identical to her own, and gave her original camera to Elaine. With the others acting as "witnesses," they loaded the cameras with fresh film and photographically marked each film to aid in identification later on. Elaine filmed a brief segment of her daughter, and Dorothy filmed the entryway. Then they went outdoors to the sun deck, faced the open sky, and both women began filming, starting and stopping at the same time. As they filmed, Dorothy asked, "Do you see those little blue lights up there next to the moon?" Elaine replied that she didn't.

After an interval of filming, they again marked each film with the same images as before, enclosing the experimental footage between the markers.

When the films came back from the developer, they were identical - almost. Elaine's film, taken with Dorothy's original camera, showed the image of the moon between the ID markers of her daughter. Dorothy's film, taken with her son's camera, showed the moon between the ID markers of the entryway - with one intriguing addition. Two little blue lights moved in a spiral alongside the moon.

By August 1976 Dorothy had acquired three different movie cameras - all Super-8 - in an effort to upgrade her equipment. She tried another experiment. From an outdoor vantage point she filmed equal segments of the same lights with each camera. The results were identical.

The Light Beings Appear

Dorothy continued to accumulate footage over the next fourteen months. Gradually, during that period, a new and exciting phase emerged in her relationship with the mysterious visitors. For the first time a particular group of "beings" made themselves evident in both form and substance. However, Dorothy's initial attempts to capture them on film proved futile. In every instance the camera inexplicably failed to operate; its mechanism jammed, or the battery suddenly lost power. Dorothy said she felt they were blocking my attempts to film them and it concerned me, but I soon realized it was just a matter of timing...the time wasn't right for them to appear on film. I think they wanted me to get accustomed to seeing them in a form I could recognize...sort of preparing me in some way."

Then, on December 10, 1977, while filming an immense, white, glowing sphere, Dorothy asked the intelligence behind or within the light to show her what they looked like. There was a sudden flash and, as the object moved abruptly to the left, a "face" appeared beside it. The elfin face was clearly visible to the right of the object - a pronounced forehead, deep-set eyes, cheeks, and even the nostrils showed plainly. Dorothy knew — somehow - that this was one of many "types" of beings that populate the universe.

In a journal entry dated January 11, 1978, Dorothy wrote: "I feel now that I'm in constant and very strong communication with the overseers...I call them Light Beings...they are all light beings in a sense, but not all are the Light Beings...the Light Beings don't look like aliens, or what we've come to

A ball of bright light hovered and when Dorothy asked, "What do you look like?" there was a bright flash and a "face" appeared to the right of the bright ball.

A sketch of the face.

think of as aliens...they're made of light and are quite majestic in appearance...sort of what we might think of as angelic. They seem to be in control, like directors, I guess. I can ask them anything, and they give me the answer. I can say that I want to see something or know something, and they almost always give me what I ask for. If I ask to see a UFO, they arrange for a UFO to show up. If I ask to see what the beings inside the UFO look like, they show me. If I ask about something in the world that might be happening, they show me and explain why it's happening. I've experienced such warmth and love when they're present that I'm certain they are angels, or very spiritual in nature. When I'm sad or worried, they show up out of nowhere to comfort me. They have form now and sometimes they take shape in my house. It's not a scary thing at all because they've always been respectful. They don't pull at me or do things to me. They've always kept a respectful distance.

A "window" appeared on the side of a disc-shaped craft. In the window several entities appeared. One was nearer and held what seemed to be a clipboard-like object.

I've tried to film them when they've been indoors close to me with shape and form, but the films don't come out as clearly as when they appear in the form of bright light. They've got the shape of a luminous person standing there,

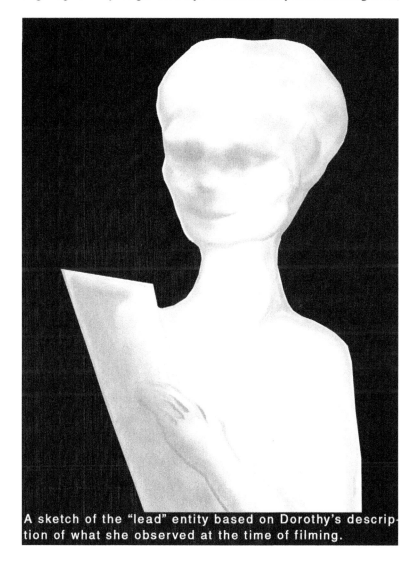

A sketch of the "lead" entity based on Dorothy's description of what she observed at the time of filming.

very tall and shimmering. I don't know if they really look like that, or if they take on a human-like form because it's easier for me to understand. I've asked them if they are ghosts or the spirits of people who have passed away, and they answer 'no.' What I see is what they are and what they've always been...beings of light. They don't mind if I film them, and so I'll continue to try, but as of yet I still can't photograph them as well in solid form as in the form of light.

CHAPTER 6

Hynek Returns

On his third and final visit in February 1978, Dr. Hynek reviewed recent examples of Dorothy's photography, and one photograph in particular caught his eye. It was a still frame from one of the films showing the distinct image of a beach scene. Dorothy explained that she had been filming a strange structured craft or solid object of some kind, and immediately before it disappeared there was a brilliant flash. When the film was developed, the image appeared where the flash had been. Dr. Hynek suggested that as the object moved away, possibly into another dimension or another position in time and space, a "doorway" had opened, and she had been able to photograph an otherworldly landscape!

"I was surprised to hear Dr. Hynek talk about other dimensions," Dorothy admitted. "But after that I felt much more relaxed talking to him about such things because the Light Beings told me there are not only other dimensions but also many other realities just as real as our own. I mentioned that sometimes, when the Light Beings appear indoors, I can see very quickly where they enter from. These are places, seemingly very solid and with very vivid colors. Dr. Hynek didn't flinch when I mentioned this. Instead, he actually seemed very interested in what I had to say.

Dr. Hynek left with more film samples, which he gave to the University of Chicago s photographic expert, Fred Beckman, for analysis. Beckman tried to create similar photographs in the laboratory, using separate colored light

Dorothy was filming a bright light in the sky when it suddenly vanished in a dazzling burst. The developed film showed this apparent "landscape" scene of hills with foliage in the foreground, and a "sea" or body of water with lights in the background. Dr. J. Allen Hynek suggested it might be a glimpse of the object's home world as it passed through a "window" or portal in time and space.

bulbs attached to motorized arms. Although he was able to duplicate with relative accuracy a few of the less intricate light patterns seen in Dorothy's films, he said that the more complex ones would take thousands of dollars to reproduce, if they could be duplicated at all.

Though convinced the films were authentic, Dr. Hynek remained puzzled as to their origin and meaning. In subsequent months, following Beckman's analysis and experimentation, Hynek shared the films with a select group of scientists, including Jule Eisenbud, a medical doctor and author, best known for his book about the controversial psychic, Ted Serios. In pursuit of his interest in the mysteries of the unexplained, Dr. Eisenbud had been in contact with people throughout the world who had taken photographs of enigmatic lights, though none compared to the volume and quality of Dorothy's work, and none produced images on movie film.

"Dr. Eisenbud asked me if I saw anything before I took the pictures," Dorothy recalled, "and actually I did. I never thought about it much, but sometimes I did see white, transparent strands. Sometimes the strands were so solid-looking that

I felt I could touch them. Dr. Eisenbud told me that he knew of others who had seen silvery strands prior to taking pictures, but he couldn't offer an explanation, except that it might have been caused by UFOs, and that some people had taken pictures indoors with similar effects. I appreciated Dr. Eisenbud's support and encouragement, but I was beginning to realize that even the scientists didn't have an inkling of what the Light Beings really were. I was just happy that they all agreed that my experiences were authentic.

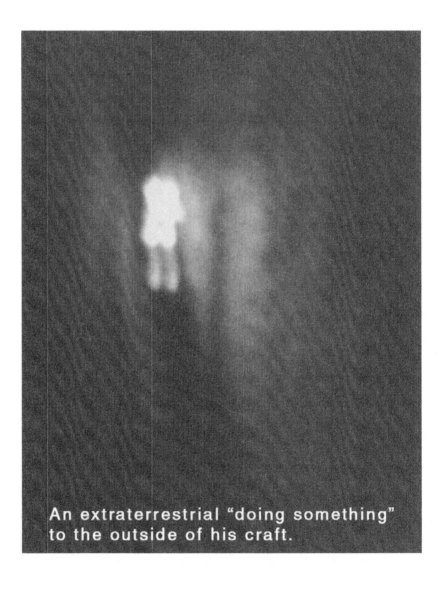

An extraterrestrial "doing something" to the outside of his craft.

CHAPTER 7 *The Speed Of Light*

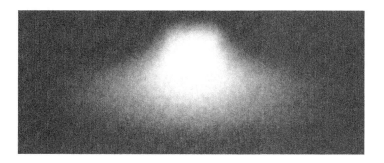

As time passed, a kind of "paging" system developed between Dorothy and the visitors. "They usually came when I wanted to see them," she explained, "and when they wanted to see me, they'd beam a light at me. At other times I'd hear a very high-pitched piercing sound. Most people couldn't hear it, but our dog could, and his ears would stand up. When they'd turn on the sound, it was as if they were saying, 'We want to see you, Dorothy,' or 'There's something here for you.'"

The objects often arrived as tiny balls of light and became larger - and closer - as the sighting progressed, sometimes growing to the apparent size of the full moon. And despite an occasional resemblance to UFO photographs from other sources, Dorothy's photography stood alone for three reasons: 1) The images were in motion on 8mm movie film. This offered the viewing equivalent of having been there when the film was shot. 2) Sheer volume. By 1979, Dorothy had accumulated over one hundred reels, and 3) while filming one or two lights that, to the eye, appeared to be hovering or moving slowly, a quick blinding flash of light would occur at intervals. Later, when the developed film was paused on a single frame in the projector, beautiful multi-colored, kinetic shafts of light appeared that coincided with the bright flashes seen during the filming. These trails of moving light were remark-able not only for their beauty but also for the mind-boggling speed achieved by the object or objects that produced them. Sometimes there were hundreds of instances of multi-directional movement in the time it took for a single

frame of film to pass the camera's shutter (1/18th of a second). No conventional or natural object could maneuver and change direction multiple times at that speed in such a confined area, period.

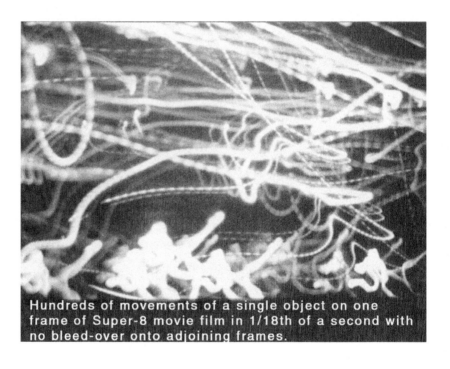

Hundreds of movements of a single object on one frame of Super-8 movie film in 1/18th of a second with no bleed-over onto adjoining frames.

Dorothy described the typical light event: "Often the little ones, the small lights, will beam at the larger one...there's usually a big light nearby and the larger one will beam at the little ones. It seems as if some sort of conversation is going on between them. Eventually, the small lights will move up close to the larger light. I've noticed a few times that when the small lights are through with what they're doing and they want to move on, they'll go up to the larger light and disappear. Apparently, before they can leave, wherever they go, maybe to another dimension or what have you, they have to go and connect with the larger light. Then, bang, they're gone.

That the lights registered on film in 1/18th of a second was obvious because the images rarely spilled over onto more than one frame. Single frames not only showed brilliant trails of colored light but occasionally revealed mysterious scenes seemingly taken from an entirely different point of view than Dorothy's. On occasion, the bright flashes of light appeared to come directly toward the camera and into its lens. "It started almost as soon as I started filming," said Dorothy, "something happened to me, some sort of energy transmission. I think that when they were beaming this light at me, they were really sending energy to me because suddenly I was able to mentally see a lot of things. Some of the films showed scenes as if I had been taking the pictures from their point of view instead of from mine. At the time I was filming, I saw a blast of light - that's all I saw. After the film was developed, there'd be a picture of my balcony from up there. I wondered how that could be. I was down here, and they were up there. I asked them how this happened and they said, 'You have to lift your energy, and we have to lower ours. We take you up here and send you back again, but it happens so fast that you're still holding your camera in your hand.' I've asked about all this again and again, and they've told me they beam these lights at me because they're helping to raise my inner being, giving me energy that has a purifying, uplifting effect. Then they feed information to me as I'm filming. We're communicating. I ask questions; I get answers. There are also little lights that are sent from other beings that use vehicles or craft. I think these beings are from other planets. The lights they send are small, about the size of a silver dollar, and can come right through a closed window, through the glass, without breaking it. I was told the little lights are used to scan and investigate. They send this light around your face, and it gives them information about what you're made of, also the kind of person you are.

In the years following her initial contact with the visitors, Dorothy realized there were at least two distinctly different classes of "life-forms" involved, even though they often resembled each other in superficial ways, such as

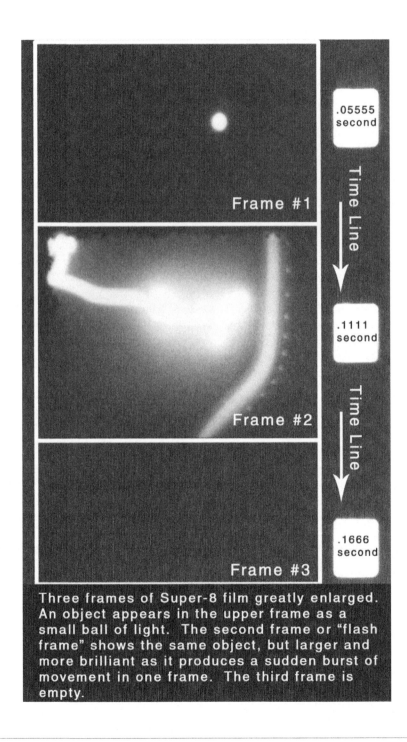

.05555 second

Frame #1

Time Line

.1111 second

Time Line

Frame #2

.1666 second

Frame #3

Three frames of Super-8 film greatly enlarged. An object appears in the upper frame as a small ball of light. The second frame or "flash frame" shows the same object, but larger and more brilliant as it produces a sudden burst of movement in one frame. The third frame is empty.

moving with extreme speed, appearing and disappearing suddenly and pro-
ducing very bright light. On the lower end of the scale were the creatures of

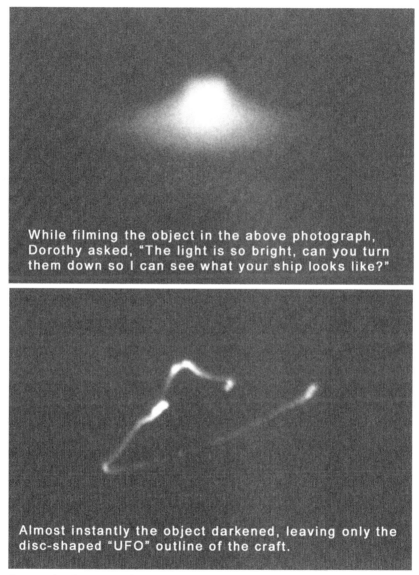

While filming the object in the above photograph,
Dorothy asked, "The light is so bright, can you turn
them down so I can see what your ship looks like?"

Almost instantly the object darkened, leaving only the
disc-shaped "UFO" outline of the craft.

form and substance. These appeared to be biological organisms that resem-
bled generally the so-called "Ufonauts" described in UFO sighting reports.
Some tall, some small, with many variations in-between, they transported

themselves by use of craft of varying types and seemed preoccupied with the immediate present or the task at hand. On the high end of the scale were the formless "beings" of energy that represented an advanced order of life. They were simply "there" or "not there," and required no medium of transport, at least none that was readily apparent. They seemed to be aware of all events taking place on earth and elsewhere and were devoted to improving the human condition in subtle spiritual ways without direct intervention. Yet despite these differences, all were linked together, not only by their shared ability to do seemingly magical things but also by their awareness and mutual respect for each other from the lowest to the highest. In an interview Dorothy put it this way:

"There are the extraterrestrials or aliens that are organic or material beings that look like us, or something like us. They usually come closer to the earth, and land, explore, observe us and how we live, and sometimes walk around and gather samples...things like that. They are sometimes assisted by lower life forms that are animals or animal-like creatures, and even robots or something like robots. The Light Beings are quite distinct from these. I now believe the Light Beings are made of pure energy and they are aware of all other life-form activities. They can take any form they choose. They can be huge in size or very small; they can make themselves appear to be material beings, but they're really not. The Light Beings avoid anything harsh and violent, or I mean they avoid direct contact with anything like that. I've called them Light Beings because it's easier for people to handle. When you say 'angels' or 'angelic,' people sort of back away and think you're trying to convert them to something religious or mystical, or whatever.

"The very beautiful displays of light come from the Light Beings mostly. This light is healing to the earth, and it's being sent all the time, even right at this moment. If they didn't beam this light down to support the good people, the people who are truly human in their spirit and wish to do right, it would be even more difficult than it already is for us. There are so many negative forces around us and in us that it's very hard for us to fight alone. It's an invisible light, and that's why we can't see it. But someone's got to show people that these things exist, that they're there. Someone's got to provide proof because we live in an age where people want proof of everything. The

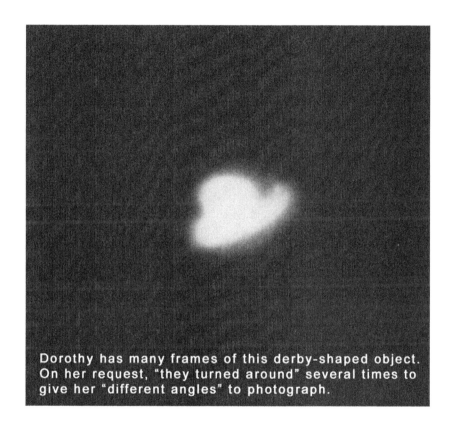

Dorothy has many frames of this derby-shaped object. On her request, "they turned around" several times to give her "different angles" to photograph.

Light Beings want people to know because they want them to have hope. I don't know why I've been chosen to film them. I mean, I'm no special person. I'm an ordinary person with the same weaknesses and the same ideals as everybody else. Why me? I really don't know. I've asked myself that question quite often, but why bother to ask? Everyone's given something to do, and if they picked me for this particular job, they had their own reasons...I believe the reason I wasn't surprised to see them, that I felt so calm basically throughout, is because I've known them all my life somehow; that's why I felt so comfortable all along. It wasn't like I was seeing complete strangers. Also, I know there's more to do, and the best is yet to come.

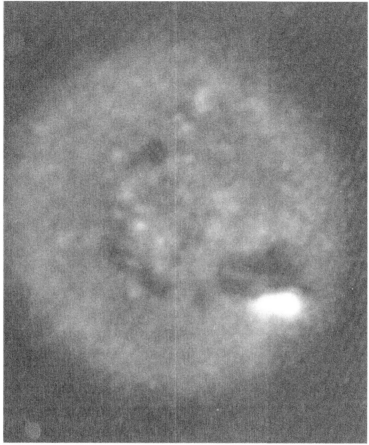

This huge ball of light emitted a bright and beautiful
blue and lavender light. A smaller object, emitting red
and white light, emerged from the lower right portion
of the larger object. Having seen this before, Dorothy
identified the smaller light was a "scout" or probe of
some kind.

Why Dorothy?

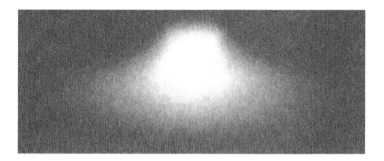

By 1979 both Dorothy and her films had been evaluated not only by scientists from five universities in Canada and the U.S. but also by a procession of curious buffs and enthusiasts. Without exception, each and every one was overwhelmed by the sheer magnificence of the photography. "Truly remarkable," said one dazzled visitor, "I've never seen anything like this. I think these films hold the key to many of our modern mysteries." But despite unanimous agreement that what exploded on the screen was unique, researchers groped for an explanation of the eerily beautiful and varied images in the films. Clearly, the lights behaved "intelligently," but what were they? Extraterrestrials from distant planets? Disembodied human souls? Ghosts? Angels? Future earthlings visiting their past? Phantom projections from Dorothy's subconscious? Though the extraterrestrial hypothesis was the majority favorite, no one had the definitive answer, and all agreed that both photographer and subject were equally intriguing.

So if the images on film were genuine, and there was little doubt about that, the next logical question was, "Why Dorothy?" Nowhere on the planet was there a single individual with as much photographic proof to back up a claim for contact with a non-earthly intelligence. Certainly there were people who claimed to have encountered lights, UFOs, and unknown entities, and there were photographs of UFOs, ghosts, and other strange phenomena, but not a single soul on record could boast reel after reel of live-action movies to vali-

date a long-term succession of close encounters with life forms from other than our own planet.

The question "why" had likewise nagged Dorothy, more so when it became clear that her contact was ongoing and evolving into increasingly complex events. She wondered why she had been "chosen" and not - in her words - "more deserving people" who had dedicated their lives to investigating the paranormal?

"I asked that question over and over again," she said. "Why me? I'm just an ordinary person. I've led a quiet life raising my family, and I've never researched anything like this. Why was I able to get my movies and nobody else could do it? Oh, I know somewhere in the world somebody probably must have pictures like mine, but all the experts I talked to like Dr. Hynek and Dr. Eisenbud, said they didn't know of anybody. After the first few months, I even asked them (the Light Beings), and they seemed amused as if to say 'what difference does it make?' After a time, probably because they were tired of my asking, they would say things like, 'we've been with you many lifetimes,' and it would leave me puzzled. Were they saying I had lived before on earth? This idea of past lives was a bit unsettling to me."

Unsettling indeed. Born and raised Catholic, the subject of reincarnation was not a familiar topic of conversation with Dorothy. "I never really talked about such things, not seriously anyway," she said, "and yet when the Light Beings told me they'd been with me since long ago, lifetimes ago, something clicked and I just felt it was true. I could almost remember being with them, or having something to do with them in some other land or country, but it just wasn't clear in my mind. I wished I could find a way to remember." And it was precisely to this end that Dr. Lee Pulos was to play a key role.

"One evening we had Lee Pulos and a few friends in to discuss my experiences," Dorothy recalled, "you know the why, how, and what of it all, and Lee said he'd like to do a regression with me at some time. He asked what I felt about hypnosis, and I said I wasn't completely comfortable with it, but I'd be willing to give it a try. I really was very interested in finding out why I was able to take the pictures so often and communicate with the lights. Lee wondered why Dorothy too. He knew the lights were real and would react to me, and he knew of no one else who could do it so often and so regularly. I knew there was something in the back of my mind, maybe some former lifetime or something like that, but I just couldn't remember...so I was will-

ing to try anything. Lee is a nice man, and I trusted him, so I thought, why not?"

Dorothy's decision to try regressive hypnosis almost at once gave rise to debate among die-hard enthusiasts familiar with her work. The use of hypnosis as a means of activating recall was controversial and experts were divided as to its reliability. Virtually no accepted scientific opinion existed about its usefulness in an activity as arcane as past-life regression. Yet, however flawed, it seemed to be a viable option - perhaps the only option - and Dorothy was hopeful that somehow it would help unlock memories of a bygone connection to the Light Beings.

Regression

In April 1979 and during a six-month period thereafter, Dorothy was regressed on three separate occasions. Professor Bob Harper and Max Bonneau of Simon Frazier University, Vancouver, and Larry DeFehr of Douglas College, Vancouver, assisted Dr. Pulos who presided over all three sessions.

At the start of the first session on April 9, Dorothy was not at all certain she could be hypnotized. "I didn't think it would work, but then I was very relaxed as I listened to Dr. Pulos' voice. He told me to concentrate on my finger and to start counting. After about half an hour of this, I guess my finger twitched without my knowing it...and I was under. I began to see moving pictures in my mind so clearly...just like before when I'd communicate with the Light Beings...thing is, they were there, too, watching...I could tell.

Author's note: The transcript below is an excerpt from the first session only. At the time of this writing, some twenty-one years later, whole transcripts of regression sessions two and three were not available. Professor Harper, Max Bonneau, Larry DeFehr, and Dr. Pulos could not be reached for comment. According to Dorothy, however, sessions two and three provided no additional information of any substance beyond what was obtained in the first session.

Dr. Pulos

Dorothy...now go back, go back to the time most relevant to the teachings of our friends/entities. Do you recognize anyone?

Dorothy

Friends...all women in white robes...I'm advising, my name is Manari and I want to try a new experiment which has to do with light...oh...I'm in a big cave, many children laughing and playing...I work with energy and crystals...firestone crystals cut into different shapes and they draw light...the crystals are used for many things depending on size, shapes...used for lighting caves, moving things in the air...that fly...the more cuts in the crystal, the more power...they come from deep within the earth...difficult to do...

Dr. Pulos

Where is your guidance coming from?

Dorothy

From an old seer in the hills. Very old is he...he's my grandfather...his name is Mani...

Dr. Pulos

Where are you, Manari? What country...

Dorothy

The waters are very blue and the sky, too...I'm in Greece...and it's a long time ago...

Dr. Pulos

How far back in time are you?

Dorothy

It's a long time ago, more than 10,000 years...I think 10,500 years...

Dr. Pulos

Was this before Greece as we know it?

Dorothy

My country is known as Lisea, formerly that of Atlan...

Dr. Pulos

Is this the same as Atlantis?

Dorothy

Yes...Atlan...I'm of the House of Atlan, Fourth Dynasty...I'm 18 years old and of noble blood...

Dr. Pulos

Is Lisea related to Micenee? And who are you, Manari? What is your role there?

Dorothy

Yes...Lisea is related to Micenee...a very beautiful place. We...we investigate energy...the sun is the primary source...and I am also a noble, as are my mother and father. I'm a princess, but we are all living in caves...about 2000 of us...and the caves are miles and miles long. We are hiding from the bad kings. They want to capture us to help them build weapons of war, and if we don't, they will kill us. But we don't want to. That's what happened to our ancestors of Atlan...Atlantis...why they met destruction. We know this is not right. I'm protecting the children. We are all laughing in the caves, but we cannot go outside. It's too dangerous for us...for the children...

Dr. Pulos

What do the caves look like? Are they natural?

Dorothy

The caves are all white inside...they are natural, but we improved upon them. The caves go on for miles. They are all white...we added some smooth, white porcelain-looking material around and we built a lake in the middle, which we use for swimming. The water is kept warm from the crystals we used...

Dr. Pulos

Tell me more about the crystals. How do you acquire them?

Dorothy

We get them from deep below...they're very difficult to extract...very deep beneath the earth's surface. We must bore down quite deep...there are two kinds of crystals...blue and white ones. We call them firestones. The old name for them is ka-light. The blue stones are closer to the surface. The white ones are found down deep...

Dr. Pulos

What are these crystals used for?

Dorothy

Many things. They heat the pools and lakes, and light the caves...we grow things with them and use them for healing by light...for moving objects through the air. We must cut them into different shapes, depending on what we need them for. The crystals are very useful...

Dr. Pulos

What else are the crystals used for?

Dorothy

Well...during the time of my ancestors, in the days before Atlan was no more, they used crystals as beacons...like a lighthouse. They used them to cut down mountains. If they wanted to build something, they would direct a beam of light, and it would help them cut the sides of the mountain down.

We use the same method, too, in the caves when we want to clean up certain parts of the caves. Crystals are also the primary way we communicate with the beings. We have a crystal on the four corners of a special screen, and in the center is where we get our information, and this is how they teach us to build flying machines. They project the information onto the screen, and we communicate through this screen...the screen I can't explain...and so in this way the crystals are used as receivers...

Dr. Pulos

Is the power of the crystals innate to the crystal itself, or is it something more?

Dorothy

The crystal is the vessel for the power, the energy that comes from it. It is a living thing. This energy comes from lots of places. We use the sun's energy, too...

Dr. Pulos

So you place the crystals in the sun?

Dorothy

No, we have to bore a hole in the crystal with an instrument in order to use energy...it was like a conduit, and then we cap the crystal so the energy will not escape...or sometimes we used special coils inside the crystal...

Dr. Pulos

So did you encounter the Light Beings in Greece?

Dorothy

Yes, we use the crystals to communicate with them. They taught us how to build flying machines or craft...the crystals act as receivers. They help us to fly away from the danger of the bad kings...

Dr. Pulos

What is going on?

Dorothy

The earth is breaking up...we need to get away, far away. Our friends in the sky are helping us with that. They've helped us build the ships that fly in the air so we can escape. We've all gone to different places. My group has gone to settle in the head of the cobra. I won't return until the land settles down...

Dr. Pulos

Is this head of the cobra what we now call Egypt?

Dorothy

Yes...but then we all eventually will go to South America. We build temporary colonies and always leave one person there to oversee things, and then we go someplace else and do the same thing...

Dr. Pulos

Are these friends in the sky UFOs?

Dorothy

No...I don't...understand...no, they're just friends, people from another...time...are helpers...

Dr. Pulos

Did you take crystals with you on the flying ship?

Dorothy

Some, yes...but others we dropped into the sea. We didn't want the bad kings to get them. Too dangerous...many had to be dropped into the sea, too, because if we had an accident on the ship, they could blow up...

Dr. Pulos

Could the crystals be found today, anywhere...in a museum?

Dorothy

No...we dropped...it...in the sea...in Delos, deep in the sea in a cave. It looks like a round ball with a rod attached to it...

Dr. Pulos

What do you remember of your parents? Were they with you at this time?

Dorothy

Yes...my mother's name is Lyhala and she was a noble as was my father who was a descendant of Atland...Mahani was his name. They were with me, but we all left the caves separately...

Dr. Pulos

So this is one of your first memories of contact with the Beings of Light? And the reason you have been chosen now to experience the photography of the Light Beings is that you are really re-establishing contact with friends from the past?

Dorothy

Yes, they're very old friends...they have always been with me...they are beings from other dimensions...and others are from many different places...

Dr. Pulos

How are you communicating with them now, in this lifetime?

Dorothy

By lifting my vibration...this comes from within, from the soul...it's hard to describe. A life force within...a sensation...a feeling...

Dr. Pulos

Why are they establishing contact again with you? What is your purpose here in relation to the Light Beings?

Dorothy

I am a messenger...need to help people...many people are spiritually sick, need help...spiritual help. Mankind has been slow to evolve spiritually, to rise up from primitive behavior and wrong actions. They are concerned that man will bring about his own destruction...within and without...

(Dorothy suddenly becomes noticeably fatigued, the range and tone of her voice changes markedly. It's at this point that Dr. Pulos chooses to bring her out of the trance.)

Dr. Pulos

All right, I think we can end here. You will remember everything you said here clearly. You are at peace and feel refreshed.

* * * * * *

When Dr. Pulos brought Dorothy out of the trance, a strained silence filled the room. Then, following a brief conference, the scientists offered a polite flurry of thank you s and went their separate ways. They were moved by Dorothy's testimony but uncertain what to make of it.

Relieved and yet deeply ambivalent about the regression experience, Dorothy was left with more questions than answers. In retrospect, so much of her trance-induced recollection seemed like utter fantasy, and yet there was something palpable and intimate about it. Her experiences with the Light Beings and various other entities from elsewhere were real; this she knew, and the films proved it. But how could she be expected to verify a past life in remote times among a mysterious people in a strange land? Could there be a shred of truth to it? She had been taught since childhood that stories about ancient utopian civilizations and "lost continents" amounted to little more than fairy tales. The majority of the world's experts pooh-poohed such things, and there was no scientifically acceptable proof of any of it. Now, for the first time, Dorothy was genuinely concerned that she might be delu-

ing herself or, at the very least, stepping onto dangerous ground that could have a chilling effect on her credibility.

"I was very concerned about it," she said, "all this about being a princess and what not. I had always thought people who claimed they were Cleopatra or queen so-and-so in a past life were fooling themselves. Now all of a sudden here I was saying the same things, and it threw me for a loop. I was afraid to mention it to anybody for fear they'd think I was really off my rocker. Dr. Pulos and the others didn't say much about it, and there I was alone with my thoughts. My curiosity was strong, though, and I felt I should try to verify some of it, if I could.

CHAPTER 10 *Manari*

Despite a determined effort to concentrate on her normal routines in the months following the hypnosis, Dorothy found herself haunted by the images and feelings that arose during the regression. Though Dr. Pulos hadn't established any posthypnotic cue words to help her consciously recall more details over time, the name "Manari" did, in fact, bring on spontaneous visualizations.

"They were quite vivid," she remembered, "When I thought of Manari's name in my quiet times or before I went to sleep at night, more images came to my mind that were very vivid and filled with vivid colors like moving pictures. I'd had those...what to call it, those waking dreams before that...Dr. Pulos told me about it, that people have them before they go to sleep, but these flashbacks were different from those...and very real-looking. It was so strange because I didn't know anything about reincarnation or anything like that. But what else could it be? I'm not sure if it was the hypnosis because I always saw these things in my mind, but they did seem more vivid to me.

Doubts about the hypnosis notwithstanding, Dorothy could not suppress heightened feelings of identification with the distant past, and with it came the half-puzzling and half-oppressive sense of being absorbed backward in time. She knew practically nothing about reincarnation, and the idea of adopting an "occult" belief was an out-and-out abomination to her long-held Catholic convictions. All of this disturbed her deeply and as the weeks

dragged on, the struggle within her intensified. In the end she could think of little else to do but what she had always done in the face of uncertainty - seek guidance through contemplation and prayer. If there was any common ground between what she had been taught about religion since childhood and the doctrine of reincarnation, she was confident it would be shown to her.

"I started praying every day and checking my Bible every day for ancient names to see if there was anything like Manari in it. I couldn't find anything at all, so one day I closed my eyes and asked for guidance before opening the Bible again. I opened it, and right there in front of me was a scene where the Apostles are asking Jesus, 'We thought you said Elijah is coming?' and Jesus said, 'Elijah was here, but you did not recognize him...he was John the Baptist and he will come again at the end of time.' So then it hit me. If Elijah was born of the flesh and then reborn as John the Baptist, who would return again, it must be reincarnation. At least to my mind this is what it had to mean, and I felt I had my answer. It had to be, because I couldn't go on fighting with myself over it.

By her own admission it was a stretch to put so much faith in a single passage of the Bible, but Dorothy was satisfied and now believed she had come full circle. For the first time, she was ready to accept the spiritual significance of her role in the strange and beautiful photography that had come to occupy so much of her life. She felt certain the Light Beings originated in a higher reality, and the ability to see them and communicate with them was determined by mysterious qualities of the soul. She theorized that in some spiritually subtle way her own inner powers, familiar to the people of a lost civilization thousands of years ago, had been gradually re-emerging since the arrival of the Light Beings in 1974.

"It was like a great load was lifted from me. That I had lived before as Manari did seem to make sense. If I had been Manari, and I had communicated with the Light Beings so long ago, it would explain why I'm able to get my pictures and communicate with the Light Beings in this lifetime. All the experts told me they knew of no one else who could get pictures like mine so often, and that always bothered me.

Acutely aware that it was not enough merely to believe Manari had lived thousands of years in the past, Dorothy wanted very much to verify the names and places revealed in the hypnotic regression. But where to begin? She was no student of ancient history, much less of mythic civilizations that no self-respecting establishment expert believed existed. To confirm any of

it would be difficult - perhaps impossible - and the thought of pursuing it was daunting. As a result, Dorothy withdrew for a few months and concentrated on her observations and filming. She refused to talk openly about Manari and the regression experience lest it threaten her credibility and cast a shadow over the authenticity of her photography.

CHAPTER 11 *Verification?*

It wasn t until a chilly winter's morning in 1979 that Dorothy began her search for some trace of Manari in the history books. She phoned the language department of the Vancouver public library and spoke to a cordial-sounding female employee who jotted down a brief outline of the facts that Dorothy gave her.

Three days later the woman called back to say nothing could be found and suggested that Dorothy take her query to the library's Ancient History department. "I called and spoke to a man in the history department and right away he seemed very reluctant. I don't know why. So, like I did with the first person I talked to, I didn't say very much, just that I had a name I wanted to know something about...he thought it was strange, I guess, but he agreed to check into it."

Nearly a week passed before the reluctant, but now enthusiastic librarian called back, describing his success in locating a small remote village in Greece named "Manaris." So old was the village, he said, that the origin of its name was unknown. The villagers spoke an unknown language, lived in caves, and shunned outsiders. The location was in the central Peloponnesian region of southern Greece at latitude 37 degrees 24 minutes north, and longitude 22 degrees 19 minutes east.

"I had to laugh when I thought about that librarian s reaction. I think he considered himself quite the expert in his field, and he was so thrilled to learn something new. He really wanted to know why I was interested, but I didn't say anything, just that I was doing research and I left it at that.

It was not the brass ring Dorothy had hoped for, but she was thrilled to know that at least a name similar to Manari was traceable to Greece, the country mentioned in her regression accounts. It seemed "right" to her, and she felt there was more to it than a mere coincidence of names.

"Something told me to call the Greek Consulate and ask them about it. I guess it was an inner voice, if I can call it that. It seemed a good thing to try because if anybody would know about Greece, they surely would. I had to get the courage up for it, though. I never much liked talking to official-type people. They're always so official...but I got up my nerve and called them.

At first, Dorothy's telephone call to the Greek Consulate was an exercise in confusion and antagonism. The switchboard referred her to a man whose thick accent made him difficult to understand. When he heard the word Manaris, he became noticeably agitated and began muttering short undecipherable phrases that seemed to convey an unqualified displeasure with the question. After several long frustrating minutes, he passed her to another man who did not speak much better English. The second man used slightly longer phrases but was, nonetheless, annoyed with Dorothy's question. Then, regaining his composure, the man abruptly deepened his voice a full octave and launched into a canned speech clearly intended to coax Dorothy into accepting information about Athens and other places popular with tourists.

Dorothy had to wonder what she had gotten herself into. Finally, after listening to a half-intelligible commercial about Greece, the man gave up and transferred Dorothy to a woman whose command of English was almost perfect. The woman apologized for the confusion and confirmed that Manaris was a small Peloponnesian village where the people lived in caves under relatively crude conditions. She urged Dorothy not to attempt to go there without an official guide because, although the people spoke Greek, they used another unrelated language known only to them, and they were not friendly to strangers. The woman was able to confirm the latitude and longitude, adding that Manaris was west of Megalopolis and southeast of Tripolis.

At the close of the conversation the woman mentioned that an important archaeological project was nearing completion among the caves of Manaris. Her tone was cautious, and she volunteered no details except to say that new and "unusual" artifacts had been unearthed that the Greek government would eventually announce publicly. This was, she emphasized, another reason the area was, for the time being, not recommended to tourists.

Even though the information was sketchy - if not downright cryptic - Dorothy was elated. There were definite parallels between the life of the people of present-day Manaris and her regression account of the life and times of Manari. The "coincidence" was overwhelming; today the people still lived in caves, spoke an unknown language, and sequestered themselves from the outside world. Could they be the descendants of Manari's people?

Several weeks later the Greek Consulate followed up with a letter to Dorothy, but it revealed nothing more than what she was told on the telephone. In fact, the majority of the letter was filled with glowing descriptions of the more popular places in Greece. Though it sounded very lavish in antiquities and no doubt a nice place to visit, Dorothy could not get the obscure little Peloponnesian village of Manaris out of her mind. The geography, the people, the history, everything seemed to work out right. It was a place rich with familiar names from the Greek mythos - Zeus, Athena, Apollo, Pan, Demeter, and Odysseus. Historic sites like the tomb of Agamemnon at Mycenae where a race of giant Cyclops were said to have erected huge granite megaliths to protect the city from marauders. Locations with evocative names like Atlantis and Mani and Manaris, all hinting at a connection to the names and places in Dorothy's regression narrative - names she had become so familiar with in her own inner imagery.

Dorothy added this rather intriguing morsel: "I remember the name Agamemnon. It sounds strange, I know, but I believe Manari knew Agamemnon. Not the one mentioned in Greek history, no, he took the name. Manari knew a king named Agamemnon, and that would have been long before the second one. The second one took the name because the first Agamemnon was a great hero to him and the people of his time. I really think some of the later history, the names and myths, were based on what the simple people of an earlier time actually experienced and passed down through the centuries. In the case of Manari, maybe it was how they interpreted the abilities of her people, which would have seemed very magical. Of course I don't know how any of this can be proven, and it's really just what I believe is true.

Despite the small victories in her attempt to verify the names and places described in the hypnotic regression, Dorothy was not completely satisfied. She knew there had to be more to the story, and yet there was little else she could do, or hope to do, to pursue it further. Her resources were limited, and there was no one able to spend the money, or willing to spend the time on meaningful research. Scientists and career "experts" were not inclined to get extensively involved, and the majority of laymen were ill equipped to do more than serve up colorful speculations. Still, what Dorothy had uncovered exceeded her expectations and provided a much needed boost to her confidence. "At least I knew I wasn't completely off my rocker. I didn't depend on anybody else's opinion. The memories and the pictures of Manari and her people that I saw in my mind were true, I was pretty sure of that...and when I got this little bit of information about Manaris, it comforted me. Even if I couldn't go to Greece myself, or find somebody to research it more, I was pretty happy with it. I still didn't feel very comfortable about telling people, though, except for a few close friends, but, all in all, I did feel more confident about what I'd experienced...so I had to accept it and, I suppose, try to forget about it, too."

Resigned to the futility of the situation, Dorothy diligently carried on with her photography, and over the years a steady stream of curious people, asking the same questions that had been asked many times before, came to see the enigmatic images on film. Dorothy rarely mentioned Manari, or the regression, but when she did she was never sure anyone believed her. Eventually, she stopped talking about it altogether so people wouldn t lose interest in her photography. Nevertheless, even in her silence Dorothy continued to feel the inner reality of Manari, and over time the need to prove the existence of the ancient Lady of Light gradually dwindled in importance.

Part Two

In Her Own Words

Except for minor editing, the following is entirely in Dorothy Izatt's own words from many hours of taped interviews. Bear in mind, in a life so rich with anecdotes and personal experiences, the task of choosing material to include here was daunting to say the least. The author was faced with a mountain of fascinating stories spanning a period of more than twenty-five years. Needless to say, for the sake of expedience much had to be left out. Knowing no other way to make the choice, the author opted for stories that Dorothy herself seemed particularly fond of.

Another important point to remember is that Dorothy Izatt has a live-action movie film record of her experiences. From the beginning she has never expected anybody to take her word for anything. The camera lens doesn't lie, hallucinate, or exaggerate. Therefore, the films and photographs add cogency to the whole of what Dorothy reports, however subjective some of these stories may seem on the surface. This was, is, and remains to this day the unique difference between Dorothy Izatt and many others who lay claim to similar personal experiences.

And finally, a proviso for those who would question Dorothy's honesty, accuracy, or cognitive interpretation of the events she describes. Here's a comment from respected clinical psychologist, Dr. Du-Fay Derr, of the Department of Counseling Psychology at the University of British Columbia:

"To eliminate conjecture about Mrs. Izatt's psychological stability, I have given her a battery of tests, including the MMPI (Minnesota Multiphasic Personality Inventory), which is the grandfather of all psychological tests. We use the MMPI test to determine what kind of personality problems a person might have. This includes things like psychosis, schizophrenia, and various mood disorders. Our tests indicate that Mrs. Izatt is a normal, average person with no psychotic tendencies, or depressive tendencies, or any type of mood disorder. In fact, all of our tests show that she's a very modest, truthful person, honest and dependable, and of above average intelligence. She's an ordinary, stable, and honest person. I believe her photographs are real, that what she is experiencing is true and that she reports exactly what she sees. There's no reason to doubt that she's telling the truth about what she experiences.

CHAPTER 12 — *The Lady In White*

One day, I think it was in 1985, I was asked to show my movies to a group of people who studied the paranormal. This group flew me up to Prince George where I was to give a lecture. The lecture hall was in a school gym and, oh, I'd say about eighty people attended. Actually, it was quite a large group for such a small community.

Once I started my movies and began talking about the pictures, the doors were closed because I suppose they didn't want more people to come in while I was speaking. I'd only been talking for a short time when suddenly a loud pounding came from the closed doors. Somebody wanted to be let in, and whoever it was really pounded on the door.

Finally, one of the people in the back of the room opened the door, and a Native Indian woman all dressed in white came in. She looked middle-aged and had long, flowing, straight black hair that was streaked with gray She was completely dressed in white from her neck to her shoes. Everything, all of it. The material looked like cotton to me, and it was absolutely spotless. It was almost too white, too pure. She wore no jewelry. There was a hush in the room at that moment, and of course I paused from my speaking to allow our new visitor to join us. She was standing not far from me at this point, and I could tell she was softly but firmly explaining to one of the organizers that she had to see me.

Well, this went on for a little while, and the organizer kept telling her she couldn't talk to me now because the lecture and films had already begun. He offered to help her himself, but she adamantly said, "No, I must speak to Dorothy." It really touched me and for a moment I wanted to stop every-thing and hear what she had to say, but that wouldn't have been fair to all those people in the room. Finally, I guess she realized that her only option was to wait until I had finished showing my films. She sat down quietly about four rows back and waited.

At one point a person sitting closer to me got up and immediately the lady in white took the seat. She was now next to me, and I could sense her presence: it was very strong, but I couldn't say anything because I needed to carry on with my films.

Later, during the question and answer session, she refused to acknowledge anyone, even me, let alone speak. It almost seemed as if she couldn't hear us; it was very strange.

Afterward, when people started coming forward and were milling about, the lady in white stood up and left without saying a word to anyone. I thought it was odd that after making so much effort to speak to me that she just left without saying a word.

Anyhow, she left through an emergency door, the kind you can leave through but not enter. It was then that my curiosity got the better of me. I excused myself for a moment and followed the lady in white. Two other people went with me. We were only seconds behind, but when we went through the door, she was nowhere to be seen...though that area was wide open in all direc-tions. She hadn't have enough time to walk out of sight, or even run, for that matter. She was just gone. I looked at the people standing with me, and we all shared in the puzzlement.

But that wasn't the end of it. The very next day I went out to lunch with sev-eral of the lecture sponsors. I think there were about six people with me that day. We went to a local hotel and were sitting in a lovely patio setting. As we sat talking, I felt a strong presence nearby. I had a strong urge to look over my left shoulder, and when I did, I saw the lady in white. She stood watching us with a soft, knowing sort of expression. Her eyes looked very feminine and deep. She was dressed in the same Indian-style all-white dress as the day before, and her hair was flowing and perfect in appearance. I

turned to my friends for just a second and said, "Oh, there she is." But when I turned to look again, which took only a second or two, she was gone!

I was so amazed and puzzled. I asked the others if any of them had ever seen her before, and none of them had. She was a complete stranger, and in a small town like this one everybody knows everybody else. They all found it very peculiar.

We spent a long time wondering aloud about the lady in white that day. Of course they all asked me if I thought she was a spirit, or a light being in physical form, or an angel, things like that. All I could say was that the feeling I got from her was very otherworldly. My friends were very perplexed and none of us could get over how brilliantly white the lady's dress was. When we thought about it, it seemed almost luminous.

The lady in white was not seen again by anybody in that small town. It was the first and last time for me as well. I can still see her vividly in my mind, though, and as time passed, I began to feel more and more that she wasn't of this earth. I always thought after that, that maybe she'd turn up in my films someday, and eventually I think she will.

The Man With The Twinkling Eyes

In the 1980s I seemed to have more encounters with beings that looked a lot like us, or maybe they took on the shape of people, I don't know, but so many looked so ordinary that you couldn't tell the difference between them and us. Back in the 1970s the Light Beings did tell me our universe is filled with biological life, many types that had a human shape with two arms, two legs, a head, and a body like us, but who were different-looking in their features. I saw some of these, too, ones with large eyes and heads, and so on. But the 1980s were a little different.

One experience I've never forgotten took place after I'd taken a job at a large department store in Vancouver. I'm not sure of the exact date, but it was a few years before I retired in 1990. Anyway, one day as I stood in one of the aisles, I caught a glimpse of a dark-haired man approaching me from my right. He was carrying a small kitchen utensil that I thought he was going to ask me about. He knew I worked there because of my name badge, so when he got to where I was standing, he glanced at my badge and said, "Izatt, that's Egyptian." "No," I said, "it's Scottish." He then repeated, "Oh no, Izatt is an Egyptian name!" I assured him that as far as I knew it was Scottish. He could see that I was a bit put off and finally said, "OK, I believe you, but it's also an Egyptian name...and I'd like you to know it's a very noble one." Naturally, I was puzzled. It wasn't unusual for somebody to remark on a name, but it felt odd to me, odd that this total stranger should start telling me about my name with such a tone of authority in his voice.

We stood there chatting for a few minutes about Egypt and such, and I couldn't help but feel there was something peculiar or familiar about this man. I couldn't quite figure it out, though. Maybe it was his eyes; they twinkled, almost shined. Other than that, he was quite ordinary. He was only about 5'4" tall, graying at the temples, and I'd say in his late fifties. His complexion was smooth and his skin was dark, somewhat Middle Eastern, and he was clean-shaven and dressed in a contemporary casual suit. I thought he must have been Egyptian by the way he looked, and because he was so sure my name was Egyptian. He did have a mild accent of some kind but spoke very good English.

All the while, this man smiled as he talked with me and never stopped looking into my eyes. The more he spoke, the more I began to wonder if he was really there to shop or just pretending. His manner calmed me, though, and I really had to wonder why he was taking so much time with me and why he was so interested in my name.

Since he seemed to know so much about the Egyptians, I decided to ask him if he ever heard the name Manari. His eyes gleamed; he smiled broadly and said, "Manari? Who wants to know?" Well, I do, I thought, but then I said, "A friend of mine wants to know." To my surprise he stepped toward me, leaned very close to my face, and said, "Tell your friend it means light, or light house."

I was surprised to put it mildly and completely speechless. I remember he stepped back as if he was enjoying the look on my face. I really wondered if he was there to give me a message about Manari, but before I could say anything, he turned and walked away. I shouted, "What do you do?" He glanced back at me and said, "I study ancient history, goodbye, we will meet again one day." I just stood there for a moment, then quickly followed him out the door, but he was gone. I realized I'd never asked him his name and had no idea who he was.

Well, for me the interesting thing in all this is what happened about three years later. I should say that during this time a different kind of thing was happening. Now the Light Beings were transporting me to places and showing me things. They were always there, sort of overseeing everything. So I never felt afraid or concerned about ETs or of any of the beings I met. I don't know how to explain it, this transporting. Sometimes it was physical, I mean my body and camera and all, and other times it was in spirit, maybe what some people call astral travel, I don't know. But both methods were very real

and vivid to me, and there was always proof in my films afterward, so I could prove that it actually happened.

One night, about three years after my meeting with the strange man with the twinkling eyes, I was transported to a craft of some kind, or at least it looked like ones I'd seen before and have on film. I've been able to film the inside of some of these craft, but this time I was there just to experience something. I was in a lighted, round room and right away I noticed a woman in red to my left. She was wearing a red one-piece jumpsuit that looked very futuristic. She responded to me as if we'd known each other for a long time...not on earth or anything like that, but from elsewhere. She had a very otherworldly feeling about her. She was attractive and tall, with long blond hair. I was seated on some sort of couch or divan that felt spongy and soft to the touch.

As I sat talking to this woman, I noticed two doorways, one to my left and one to my right. Just then two men entered the room. One man was tall and the other man was short. It took a moment to realize it, but I recognized the shorter man as the same man I talked to in the department store, the Egyptian-looking man with the amused expression and twinkling eyes. The other man just followed him, I guess like a bodyguard or companion.

After a moment, the man I recognized came over and stood behind me. When I looked up, he leaned down and kissed me on the forehead. He then turned to the woman in red and said, "I hear you're going shopping; that's OK, but from here to the Urals you must spend very sparingly, but from the Urals onward you can spend as much as you like." The odd thing was that when he said this, none of it surprised me. I completely understood what he meant and took it in stride.

When the man and his companion left, I talked with the woman in red for a while longer and then, in the blink of an eye, I was brought back to my home. I remember feeling elated afterward, but puzzled. There was a message in it for me, but I couldn't understand what it was.

Many months later I happened to mention this experience to a visiting friend from overseas; I think he was a member of MENSA. Anyway, he was very knowledgeable about world affairs and when he heard my experience he said, "This may not be as strange as it sounds." He went on to say that someday in the future it's likely the Ural Mountains of Russia will yield great wealth in valuable minerals and metals. So he wondered if my experience was a glimpse of the future? This felt possible to me because many times the

Light Beings told me that the past, present, and future were one in the same. Maybe this was it then; maybe I had been taken to the future? What's interesting, is that many years later I saw a TV program about scientists in Russia who were investigating the Ural Mountains and found some kind of very rare metal there. I guess this was something of great value. So who knows, maybe Russia will be a wealthy country again some day.

Later, as I thought about this experience, I remembered that I'd seen the man with the twinkling eyes even earlier. This would have been in 1974, I believe, close to when all this started happening. One night three men appeared. They appeared in light, of course but were very solid looking. One of them was this Egyptian-looking man, I'm sure of it, but his clothes were different, more like a uniform of some kind. They came in one after the other, and he came in first. One of the others looked European and had long wavy hair. The third one was fair with short, almost silver-white hair.

Following these three were other beings, a whole group of them. I thought the men were the leaders of these other beings, or so it seemed, or maybe they were showing me these other ones, I'm not sure. Some of them looked like us, and others were very alien-looking with big heads and large slanted eyes and skinny necks. Others were very small and had something that looked like flowers around their hair. They had little tilted noses and bowed mouths like dolls. Among these were still others that were elf-like and very tiny. All I could think was that this was a small sample of what is was like out there in our universe.

The Night Of The Green Mist

Among my films is one particular frame that shows a man's face close up. Many people have been amazed by it because it's so clear, and it stands out in my mind because of how I got the picture.

I believe the year was 1985. Duncan and I were both looking out from the balcony when we saw this green mist. That's the only way I can describe it. It was a bright green fog with a yellow tinge to it. I saw it first and called Duncan's attention to it. He thought it was just mist, but a green fog seemed rather odd to me. Neither of us had ever seen anything like it.

After a few minutes the mist began to disappear, and we went into another part of the house. A few minutes later Duncan came to me and said, "It's back." It was then I decided to pick up my movie camera because over the years I d realized that when anything strange happened I'd better have my camera ready! And this mist was strange to me. For one thing, a mist is supposed to rise up from the ground but this one was open at the bottom, hovering in one place like an arch or ring. I could see the buildings and city lights underneath and the sky above.

So I got my camera and went to the balcony. I didn't see anything, no UFOs or unusual lights but felt something there, so I pointed my camera at the fog and starting filming. Nothing happened, except the mist started to dissipate and after a few minutes it was gone.

When I got the film developed, I was shocked to see a UFO right where the fog had been. Actually, there were three types of UFOs on the film. One was round; the other two were little gold triangles. What was interesting was the face of man staring, and almost leaning, right into the camera. He had dark hair and a large forehead, or it could have been a receding hairline. A light shone in his left eye as he looked directly into the lens.

Over the years people have told me about green fogs turning up in various places, and that these might be doorways to other worlds and so on. I don't know, but a green mist was definitely there. Yet when I filmed it, all these beautiful pictures came out. The man s face is particularly interesting to people who see it on film because there s some slight movement to it.

CHAPTER 15

To See Or
Not To See

People were always asking me to go with them to various places so they could watch me film. Sometimes they would bring cameras themselves, hoping to get their own picture or simply taking pictures of me doing the filming.

In 1992 a professional video production company asked me to go to the Cypress Bowl in northern Vancouver. They wanted to see if they could film what I might film, and I remember it was a very cold night, drizzly, cloudy, and miserable.

So, cold weather or not, I went up to Cypress Bowl with them where they spent a lot of time filming the sky, and filming me here and there. The strange thing was that when I pointed out two lights that to me were quite vivid, they were unable to see anything at all. I was quite surprised because the lights were right in the middle of the sky, and clearly visible to me. It was somewhat overcast and quite dark, but we could see the sky, each other, and things on the ground around us. The craft had two lights on either side of it, but even when I pointed to it, they couldn't see a thing. I'm sure it was very frustrating to them.

Anyway, there it was with the two lights, and I could see a drawbridge sort of thing in the middle that swung down and widened at the bottom. I don't know what else to call it because it looked like the drawbridge on an old cas-

tle, but one made of light. There was a brighter light at the end of the draw-bridge, and I could see the rails on either side.

I told them to, "look, right there," and pointed, but they still didn't see it. Walking in the direction of the lights, I began filming as they stood there, completely puzzled. Even if they couldn t see the craft, I thought they could at least see the lights. The craft was harder to see, of course, because it was behind the lighted drawbridge. But they couldn t see anything at all and didn t know where to aim their camera.

As I filmed, they debated whether they should point their camera into the darkness and try to film or just let me do it. Listening to them, I had to won-der what I was doing there at all. I got so cold that I went to sit in the car, but after a while something told me to go back outside and try filming again.

I never question these things, so I took my camera and went outside again, but a strange thing happened just as I got out of the car...I felt inner self leave my body. It just jumped out of me, that's all I can say, and went in the direc-tion I intended to go. I could actually see myself, and I know that sounds strange, but it was very strange to me, too. At first I saw myself as a mass of light, and then as a shape. It was such an odd sensation. It makes me laugh to say it now, but I followed me from about two or three yards behind.

I thought I'd better film this, and so there I was filming myself walking in front of me. After a minute or so, I noticed a large craft straight overhead, and beings inside it were waving to me. Holding the camera in my hand, I raised my other arm and waved back, and right in front of me, my other self mirrored that same gesture. This thrilled me because I managed to film the craft as it was leaving, and I filmed my other self waving as I waved.

Afterward I asked the others what they were doing while I was filming the craft? Again, and this was so frustrating because they hadn't seen anything at all, even though, to me, the light was so bright and the craft so big that I thought there was no way they could've missed it. As it was, I might as well have been standing there alone.

Finally, before we left and went down the mountain, the group contented themselves with getting more pictures of the surrounding area, the harbor, and me, with my camera. Even as we drove away, I filmed yet another light in the sky...one that they were, again, unable to see.

What surprised everybody later, and I'm not sure they completely believed me before, was that everything I saw was right there on the film when I got it back from the developer. Everything, even the light I saw on our way back down the mountain. They were very puzzled and asked me if what they were seeing was the same footage and so on. Fortunately, I had filmed the lodge up there, too, and some of them as they stood around. There were no splices in the film, so they could see it was the same footage and not something else. The sad thing was not only that they hadn t seen anything, but they hadn t gotten anything on film, either. Even when they had tried pointing their camera where I was pointing mine, nothing showed up on their film.

A similar thing happened a short time later when a Japanese film crew came to see me. They had heard about my films and wanted to do a story for a Japanese television program. There were nine of them who first came to interview me at my home. I had to speak to them through an interpreter, and they were all very pleasant and polite. Unlike many people who come only to see UFOs and the like, the Japanese felt there was something spiritual in my work, which I thought showed unusual insight on their part.

They asked me questions about various things, and after a while the interpreter said they had heard about my visit to Cypress Bowl, which I think came from one of the people in the group who went there with me. They wondered if I would mind going again. Naturally, I didn't want to disappoint them, and so that evening I once again headed up to Cypress Bowl.

When we got to the top of the mountain, the weather was windy, cold, and cloudy. Of course they wanted to see UFOs right away, but I told them it wasn't up to me, that I couldn't make the Light Beings or even UFOs just show up. All we could do was send out the thought and wait. They kept asking me to try to make something happen, and finally I gave in to their wishes, concentrating hard for a while. Eventually, a patch of sky did brighten with a light that seemed quite bright to me, but they didn't see it. A few of them could only tell that the small patch of cloud-covered sky faintly glimmered a little, but they weren't too impressed. It reminded me of the other group because they were so frustrated that a UFO didn't just drop down in front of them with blinding light. So they interviewed me for a while and we left. I knew they were disappointed that more didn't happen, but it seems to be that way sometimes.

I have to say that even though this happens, many people have seen lights and UFOs with me. I want to make this clear because it has been said by some that I create the lights on film with my mind. That's not so because others have seen what I film as well. Often there are only glimpses of light, or of distant lights in the sky, but on very rare occasions it will be closer contact. When the people from the television show, Unsolved Mysteries , came to interview me, I pointed to a light in the sky, which they also saw and were able to film as well. The thing is, all they captured on their film was the distant light and nothing else. I filmed the same light with my little camera and caught much more activity. Whether somebody can see the lights, or film the lights, or communicate in some way is really up to the Light Beings or the UFO beings themselves, as well as the spiritual or inward condition of the person.

In the past I've tried to make all this clear by explaining something that the Light Beings told me very early on when all this first started. People shouldn't feel bad when they can't see what I see right away, or when they can't take pictures exactly like I do. There's really a very simple reason for this. In the beginning my eyes were red and irritated all the time. Sometimes I looked like I had a sunburn, even though I hadn't been out in the sun at all. The medical doctors couldn't find anything wrong, so I asked the Light Beings why this was happening, and they told me they were raising or purifying my body and my eyes so that I could tolerate the light better. This light is so intense, so strong, so different from ordinary light that it can burn a person. The Light Beings have the ability to be as bright as sunlight. What I see, and what shows up in my films, is a sort of turned-down voltage, so to speak, or just what can be tolerated. The light doesn't just touch the eyes, or the flesh, but penetrates to the spirit. For that reason they won't come close to just anybody at any time, or not so close as to blind them or burn them, or disturb them in some inward way. The eyes need to be conditioned and raised up, not only to see the Light Beings but also to be able to tolerate close contact with the light. The whole person must be purified or raised up in this way before there can be contact with these beings. That's the reason, I think, that many people can't see them, even though the Light Beings are there all the time, and even though many people are very sincere and would love to have the experience of close contact. This is why the Light Beings don't just show themselves anytime somebody wants them to. The same is true with certain types of UFOs. If you get too close to them, you can be injured. So there's no reason to be disappointed because it's for your own good. They need to understand and get in touch with the light within themselves before they can be in touch with the Light Beings. All kinds of people

just rush about willy-nilly looking for answers to UFOs and such, but I don't feel they can have a deep experience until they acknowledge and develop the light within. Otherwise, it's just ego, arrogant self-interest, and curiosity. This light within is the true meaning of my pictures; to make people aware of the light within and how it must be made to correspond with the light up there.

CHAPTER 16 *Coney Island*

I've seen and filmed many types of beings over the years; some were physical beings, and some were not. The Light Beings are not, of course, but there are many, many other ETs that have bodies like we do and need to travel in flying machines or craft of various kinds. I clearly remember one time when some sort of physical being in the form of a tall man appeared, standing just outside my bedroom window. I wasn t afraid, partly because I was used to these kinds of things but also because I felt I already knew him. It's strange, but this feeling of familiarity is always present in my encounters. I can't explain it, but it's like I've known them all for a very long time. People are so amazed that I don't shake in my boots when these things happen, but it has been going on for so many years now that it just doesn't scare me. I've heard about abductions and people being made to have amnesia and things like that, but it has never once been that way for me. Even when I've had encounters with what some called the Grays, or the little ETs with large heads, they never imposed on me or made me feel afraid. So it doesn't bother me one bit.

The man at my bedroom window must have been close to 7 feet tall. He was a slender figure dressed in a one-piece reddish-colored outfit something like a jumpsuit. He had blond hair and a kind, human, face. I guess you might say he looked like a basketball player. Under his arm he carried a white helmet, with small symbols or shapes on it that were sort of orange in color. Somehow I knew he was inviting me to go somewhere. I noticed that a small craft

Alien hands. From an example of Dorothy's remarkable "interior" footage (filmed while inside an otherworldly craft), this still shows the arms and hands of an extra-terrestrial. The right hand indicates only four digits with what may be webbing between the fingers. The alien's left hand is on what seems to be a control instrument.

A sketch of the same photograph based on computer analysis of the image.

was hovering behind him and above my backyard. It was a big area back there, and the craft just hovered silently. It was a small one really, about the size of my living room.

When I went to the window and opened it, he spoke, or seemed to speak in good English. I know this sounds very weird, but he asked if I'd like to go to Coney Island, the amusement park. I had to laugh, how strange, an amusement park? And of course no one can say I was dreaming or anything like that, because I filmed this man.

Anyway, there I am at the window and this tall man says he wants to show his daughter the place called Coney Island. I had never been there in my life and didn't even know what it looked like, but I knew it was far away and that was all I knew.

As soon as I said yes, I found myself inside the small hovering craft. I don't know how it happened. I was in my bedroom and then in the blink of an eye I was in the smaller craft. Once in the small craft, we went up to a much larger triangular-shaped one where the daughter was waiting, and the next thing I knew we were on our way.

We traveled in the larger craft, and there were other people there. One was a woman who may have been the man's wife. Two others were sitting down. The daughter was quite tall, too, but I'm only 5 feet tall, so everybody looks tall to me. The daughter, I think, was a teenager and she came up high to the man's chest, so she was fairly tall, too. They all looked ordinary, except for their height, but there are lots of tall people in the world. Their eyes were a little different, having a kind of brownish-pink color to them. But this wasn't extremely noticeable, or odd enough that it would stand out too much. I think they could walk among us, and nobody would pay that much attention to them. They were tall, slender, and graceful in their movements, and all the proportions were normal, giving them the appearance of ordinary humans. In today's world where everybody is used to seeing tall people on television and in the movies and so on, they wouldn't attract a lot of attention, not really.

So off we went to Coney Island. When we got there I was surprised that the craft just hovered above an open area. The amusement park below was blazing with lights and signs, and the craft just hovered over the top of them. Then, just as suddenly as before, we were on the ground among all these people. I don't know how they did it. It was so quick it took my breath

away. The big triangular-shaped craft remained right above us. It was fairly high up, but because of its size, I could see it plainly. I asked the man if he was concerned that people on the ground might see the craft, and he said they wouldn't even notice it. I realized he was right, because if people didn't know where to look, they wouldn't see it. Even if they did see it, in all the lights and movement they'd probably ignore it anyway. Interestingly, I realized then that he wasn't speaking to me with a voice. He'd look at me, and I could hear him speaking, but it was mind to mind and not with spoken words. I started doing it too. I'd think to say something and he'd answer me. It's really quite easy to do, or at least it was for me.

Filmed inside a "UFO," this photo shows a "railing" that ran along the bottom edge of transparent glass-like cupola or dome.

We started to walk and look at things, and the daughter was quite excited by everything. She was really enjoying it all, laughing and nodding her head and looking up at her father. He told her this was a place where children came to have fun and enjoy themselves. People scurried right past us, and

some of them looked at us, but in the glare and noise of the place, they didn't stop and stare or anything like that. There were street performers milling around, lots of people, and kids with wild hairdos like they have nowadays and that sort of thing. In that mixed crowd we didn't look particularly strange at all. We just walked at a leisurely pace, taking in all the activity and noise and hoopla, and after about an hour they decided they'd seen enough. I felt the man was growing anxious about getting back for some reason.

"It's hard to film you when you're flying all around." So the bright balls of light "gathered together" for Dorothy's camera.

When we returned to the hovering craft, I noticed that on each of the three corners underneath the triangle, there was a layered section that came down and in each of these layers was a small craft like the one I first saw in my backyard. I asked, and the man said those were craft they sometimes used for exploration or for shuttling and short trips to various places. My feeling was that the little craft are never very far away from the larger one.

From the ground we made another of those quick transfers, or whatever, into the big craft and left, and in seconds we were back at my home. We said our good-byes, and they seemed genuinely sad to see me go. I thanked them for inviting me, and in an instant I was back in my bedroom. On my film you can see the man and his daughter inside the craft, and the craft itself as it s

leaving. I felt very happy afterward and thought about it for many weeks. This always has been one of my favorite experiences, probably because it was so joyful and innocent...and because I was honored to be included.

Lights In the Living Room

One day about 4 o'clock in the afternoon I was sitting in my living room, quietly doing my meditation. This is a kind of quiet period I observe each day, sometimes with prayer, other times with a feeling of stillness and quiet in a state of submission to God. Anyway, as I sat there, all of a sudden these lights came into the room, one after the other, and alit on the carpet in front of me. They were somewhat dim at first but became more pronounced, extending all the way into the hallway that leads not only to my front door but to other rooms as well.

I was so surprised that I just sat there and watched for what must have been ten minutes before it occurred to me that I should get it on film. I walked right passed the lights, got my movie camera from another room, and returned to my chair. As I began filming, the lights started moving here and there and down the hallway. The light they emitted brightened and reflected off the walls. I could tell they were little beings encased in light.

After a few minutes several of them formed a circle around a larger one, and more and more of them came and joined the circle. I had the impression the smaller ones were trying to help the bigger one for some reason. It was just a feeling I had, but it seemed the larger one was weakened somehow, or had lost its power to grow small or something. That's just what I felt about it as I filmed, because the one in the middle was so much larger. It was almost as if the others had come to rescue it or to assist it in some way.

As I went on filming, more and more of these little lights showed up. There was a lot of activity going on, and every time there was a flash of light, more would come and others would disappear. The interesting thing was that, occasionally, some of them would go through the wall and appear on the other side. They would rest on the carpet, then rise up, and go into the wall. I have all this on film; the beings are there and the light from them can be seen reflecting on the walls and on my furniture.

I could see their faces and features quite clearly, and except for being so small, they looked like tiny people with heads and bodies, and two arms and two legs. Really, and I don't know how else to describe it, they were human beings in miniature, tiny glowing people gathered there on my carpet, all gathered around the bigger one. Some moved forward and back, and when others left, new ones arrived. I think they came to visit, and one of them had a problem of some kind.

This whole thing went on for many minutes until whatever they were doing was finished; then they left. It's all there on my film for people to see. I've always thought it interesting that so many of the beings I've seen are like us. Some are taller or shorter, and some have larger or different-looking eyes and ears, and larger heads maybe, but they all walk upright on two legs and have two arms, and so on. Some of them don t even have to walk, though, they just glide, not touching the ground at all. And still others have no need of voices, as we do, to communicate.

Many people who come to see my films ask me if I do my filming only at night. Of course the answer is no; I've filmed during the day and during the night. Others want to know if I film these things only in the sky outdoors, and again I say no because over the years all sorts of beings have allowed me to film them indoors as well. Nobody has to take my word for it because the proof is there on film. The little beings on my carpet are there just as I describe them, as are many other similar experiences. I have films of beings and lights in my house, even film of my ceiling becoming bright with light and opening up like a doorway to another world. I have many other examples on film of this sort of thing.

I should mention that this was about the same time that I discovered something very strange about my pictures. The light in them is alive, by that I mean it doesn't matter whether a person sees the lights exactly when I film because the images are themselves alive. I noticed this quite by accident one day when I was looking at a still photograph I made from one of my films.

Suddenly I could see light jumping off the photograph. I wondered if my eyes were playing tricks on me. To be sure I wasn't seeing things, I got my camera and filmed the picture. Sure enough, the picture's image changed. The light moved and came out of the image, and so on. Then I found that I could communicate with the light in the image. I said can you give me all blue, or all red, or whatever color, and it did, and all of this is on film. Because of things like this, some people wonder if this is something I do with my mind, but I'm sure it isn't anything like that. I feel it's because, to the beings, there's no space or time as we know it, not really. Time, or space, or physical barriers don t limit these beings, and they can do anything and use any means to communicate with us. I feel that people who see my films and pictures will receive something for themselves right from the images, and they don't have to do what I do, or be with me, when I film.

CHAPTER 18 *Little Lights Lost*

Throughout the years quite a few people have seen unusual lights when they've been with me somewhere, and one of those was my sister, Esther, who has shared my experience many times. Once, when she and I were on vacation, I was awakened from a deep sleep late one night by a sound. The room was very dark and Esther was in the other bed sound asleep. Seconds after I opened my eyes, a whole bunch of little balls of light appeared and began dancing everywhere in the room, casting light on the walls and ceiling. I sat up in bed and watched them move around me for several minutes; they would come close, then move away, then dart about. Suddenly, while all this was going on, they took form, and I could see they were tiny beings. They didn't have bodies as such, but they were cute looking with little scrunched faces. I couldn't see any legs or arms, just their faces, or what looked like faces to me. I had seen them before, so I wasn't too surprised.

The little luminous faces were coming toward me and swirling around as if they were delighted to have my attention. Just then somebody outside in the hallway slammed a door, and at that instant all the faces turned back into balls of light. The sound of the door slamming must have startled them. Well, the noise must have wakened Esther, too, because right then she sat bolt upright in her bed. I just kept quiet, kind of chuckling to myself, and waiting to see what she would do. Finally, I couldn't help it, I started giggling when she let out with a blurt, "Oh, what are all these lights in the room." When I began to laugh out loud, she said, "It's not funny, what are

they?" The poor thing, I guess it would be shocking to wake up suddenly in a dark room and see strange lights floating all over the place. I told her not to worry, that I had already been watching them for quite awhile. She kept saying, "ooh, uh, oh my goodness." I responded with a mixture of words and giggles, which my sister didn't appreciate too much, and told her that I'd seen them before, and they were really quite gentle and friendly. I think they sensed her anxiety because they moved around the room for just a short while longer and then disappeared.

Now this is going to sound strange, but I've seen those little beings on and off many times before and have communicated with them. They come from somewhere beyond our atmosphere, and for some reason, I don't know why, they came to me. Maybe it was because I could see them, or was friendly or open to them, that they felt I could help them. I don't know. I'm sure other people have seen them, too, because people have told me about small lights they've seen among the trees or in various places, and I think perhaps in some cases, they were these little beings.

Why they came to me, I don't know, but apparently they're trapped here. I know this sounds pretty weird, but they told me that each time one of our space devices, such as the Shuttle, returns from space, it drags some of these little lights with them, or they have done this on occasion. I don't know that it happens all the time, but it happened in the past, and it seems quite a few of them were pulled down to our planet in this way. The little beings don't want to stay here; they want to go back, but they can't seem to do it. So they used to come to me to ask me if there was some way I could get them back to where they came from. Maybe they saw my interaction with other beings or something, I don't know. I was puzzled and felt sorry for them, but I didn't know what I could do about it.

This bothered me a lot, and every time I watched the launching of another space rocket on TV, I thought I about those little beings, wondering if any more of them were being brought down here. I often wondered about the time long ago when one of the astronauts reported all kinds little lights or particles sprinkled around his ship. I remember the experts said those were ice crystals or something like that. Were they? Or were they really those little beings?

I had no idea what I could do, but more and more of them kept coming around, so one day I said why don't you just go to where they launch the spaceships and go back up? I know it sounded too simple, but that was all I

could think to say. I felt bad for them because they seem to live in space rather than on a planet. I m not sure to this day if they acted on my suggestion, but there have been fewer of them in recent years, so maybe they hitched a ride back up to where they belong.

The underside of a large disc. Dorothy filmed this object while visiting relatives in Australia.

One Stormy Night

Duncan passed away in 1989. Although he wasn't present in very many of my experiences or encounters, he was a dear, patient man, who never attempted to stop me from doing my filming. He preferred to carry on with his normal activities and let me do my own thing. He put up with a lot, too, what with all sorts of people coming to visit me, and my visits to places here and there, not to mention all the strange things going on.

There was one particular incident that was very strange, even for me, partly because it happened while Duncan was in the room, and partly because of how it took place. I've only told this experience to a few people because it was one of those times that I didn't have a chance to film, even though I believe I did film the same craft at another time years later.

We were visiting relatives in Australia; in fact, we'd just arrived earlier that day, and Duncan and I were sleeping in the downstairs bedroom. It was very late and, as I recall, a stormy night with thunder, lightening, and gusts of wind. So there I was, and for some reason I woke up rather suddenly and noticed a greenish light in the room and two beings standing there, looking at me. Duncan was sound asleep and didn't move. The two beings, or entities, I don't know what to call them, I'm sure they were androids or some other artificial types, were standing there at the foot of the bed, holding rods in their hands. They were only about four feet tall, and this is what was so weird, they had very gentle-looking cow-like or calf-like faces. Their eyes

were big and wide-set, and they had little muzzles or snouts, but their bodies were human in shape with two arms and legs. They were wearing what I can only describe is a sort of scuba diving suit, or that kind of one-piece style of outfit. Their clothing looked green, but that could have been because of the green glow in the room. Later on, when I could see the clothing more clearly, it did seem to be a light green in color. As strange as it was, there was nothing frightening about it. They had very mild expressions and didn't seem at all threatening. I was surprised but felt calm; I could tell they were friendly and that they were there for a reason.

Afraid that I might wake Duncan, I pushed off the bedcovers and got out of bed slowly. I was never sure how my husband would react to something like this because he'd made it clear to me many times that he preferred not knowing too much about these things. He didn't move and continued to sleep soundly as I got up and put on my robe and stood facing the two little entities. It was such a weird scene; there was thunder, there were flashes of lightening, the wind was blowing, and the two entities just stood there in this faint green light with serene expressions.

Then one of them came over and handed me one of the rods. It was a shiny silvery white color, very light in weight, and I'd say about a foot long and maybe two inches in diameter. There were two buttons on one end of it. I said, "What do you want me to do with this?" The one standing closest to me said they wanted me to go with them so they could show me something. At first I spoke, but they didn't; instead they used their thoughts. I looked at Duncan, thinking that all this was going to wake him up. At that point the one standing near me told me not to worry, that my husband wouldn't waken because one of them would stay behind in the room. I guess that meant as long as one of them was there, he could keep watch and be sure Duncan didn't waken. I remember feeling very relieved. As weird as it sounds to some people, and it even sounds kooky to me sometimes, I'd gotten so familiar with these types of things that it didn't bother me anymore. Knowing Duncan would stay asleep was a relief, not only because of how he might react to these strange-looking entities if he woke up and found them there, but can you imagine his concern if he got up and found me gone?

One of the entities went to the window and pressed a button on the rod he was holding and, boom, just like that he passed through the window. I was so amazed; how could he do that? Mind you, these were security-type windows because we were on the ground floor of the house. My relatives had

those metal bars on the windows for protection. But this little entity went right through as if it wasn't even there.

As he went through, he told me to follow him. How can I do that, I said, I can't go through the wall and the window. He said, "Push the button." So I pushed one of the buttons and nothing happened, although I did feel suddenly lighter because I was levitating a bit. It's an odd feeling because my body felt weightless, making me feel a bit out of control for a moment. He said, "Now push the other button." I pushed the other little button, and suddenly I moved toward the window and was outside. It was truly something like they do on the television program Star Trek, that's all I can think of to compare it to. But there was no twinkling or crackling or any of that; it just happened instantly.

So it was like that, and I pressed the button on the rod and I was through the wall and the window. I think there was some kind force field set up, too, because I didn't feel the rain or wind, and yet it was blowing hard all around us. Once I was outside, I could see an enormous round cylinder-shaped craft hovering above; the entity flew up toward it and I followed him. We went through an opening underneath the craft. The opening was like a big doorway with a ramp of some kind in it, or it seemed to me that a ramp would come from it. There were windows above it, extending on either side.

When we arrived inside the craft, I could see that there were two levels to it. The upper level was shaped like a huge dome. I remember being very nervous because I was gliding through the air. I felt terribly wobbly, and when we got to the craft, we moved around the interior in the same way, but by then I was getting along a little better. There didn't seem to be a speed control with it, I just moved at a pace identical to the little entity in front of me, and wherever he went, I went as well.

The craft was extremely big. Later, I tried to estimate its size and all I could think to compare it to was maybe a football field. I'd say it was almost the size of a football field. The interior was immense and airy and very clean smelling. I noticed that around the dome was a catwalk or a walkway with a railing that people were walking on, going here and there and to other parts of the craft. There were a lot of human beings there, or people that looked like human beings, but I don't know if they were from earth, or from somewhere else. There was also another ordinary-looking man who seemed to be a leader. He was dressed in a blue or indigo-colored uniform of some kind and wore a cloak-like garment with gold trimming along the edges, on the

cuffs, and at the spot where a gold clip held the cloak on. His hair and eyes were dark, possibly brown. As he walked passed by me, I noticed a brownish, parchment-like paper rolled into a scroll in his hand. He was walking and looking at us flying around. He smiled, and I assumed he knew I was getting a tour of the place.

He walked away and went into a room down from where I was. I followed the little entity who brought me here, and we moved around a bit, looking at this and that, eventually coming near the room the man had entered. Looking in, I saw a raised platform that looked like a big table to me. The man in the blue uniform was standing there at the table, and the paper he d been carrying earlier was laid out flat on the table where he, and several others, were looking it over. That's when I noticed that some of the other people at the table were different in appearance. They all looked human, not like those crazy-looking characters you see in the movies or anything, but they were slightly different from one another. Each wore a different uniform, though the one-piece styles were somewhat alike. Some of them were quite slim, others shorter and broader, while others had slightly larger eyes. Except for these slight differences, they all looked like human beings. I couldn't see too much detail because I was some distance away, but I watched this scene for a while, and from there we continued to look around a bit. It seemed quite busy everywhere I looked. I just couldn't get over the size of the craft; even though it almost felt like an arena, it still somehow seemed very light at the same time.

After this I was taken back to my room just as quickly as I'd left it. I gave the rod to the other little entity and the two of them left. I just stood quietly at the window for a while, thinking about how truly amazing this universe of ours really is. Duncan was still asleep and breathing deeply. He turned over a little, looking very comfortable, so obviously nothing had bothered him while I was away. When he got up later, I told him about it, and he just nodded as he always did. He was such a dear; I'm sure he knew by then that something was going on with all this, but he liked knowing as little about it as possible. The feeling of flying around with that little stick in my hand never left me. It was truly remarkable. I'm sure there will be people who will think I only dreamed I passed through walls and flew around, but it was very real. I could feel and smell the air, touch my clothing, and hear sounds. It always amuses me when people suggest this sort of thing, because most people know the difference between a dream and a real experience...and so do I. Besides, many examples of these sorts of experiences can be seen in my films, and no one can say that my films are dreams. My camera lens has

been my best friend in all this, and nobody can deny what they see in my pictures.

CHAPTER 20 *With The Light Beings*

Of course it's different with the Light Beings because they're angelic and very high level, and in that way unlike the others. By that I mean a person can't go anywhere with them in physical form. It must take place in the spirit, or as some call it, the inner self. They always come for me in a very bright light that I've captured on film many times. With a little practice anyone studying my films can tell the difference in the quality of the light.

One night not too long ago a bright light wakened me in my room. I remember covering my eyes for a moment because the light was so bright. The Light Beings were there and said they wanted to show me something. I agreed and immediately felt myself leave my body. I wasn't sleeping; I was wide-awake when this happened, mind you. I'm always aware of it when it happens, and I was fully conscious. It's never unsettling in any way because they're very gentle, beautiful beings. They're made of light and have no form, as such, but when they appear to me, they have form and are dressed in what looks like glistening robes but is probably a shimmering light of different hues. It's hard to describe, but it's beautiful to see.

Let me explain something, there are many kinds of angels. I don't think people know this, really. There are high angels, like the ones we've all read about and call Archangels, like Gabriel, who chose to be God s messengers and only do work that s of great importance. Lesser angels handle smaller tasks, sometimes involving people on earth. There are millions of them

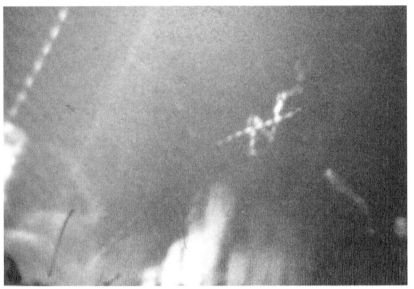

Dorothy's images occur in a medium of light. Her little low-tech camera is often overwhelmed by the intensity and unusual quality of the illumination. According to Dorothy, these photographs show the "occupants" of an otherworldly craft. At first glance the photo appears to be nothing more than a random display of various shades and hues.

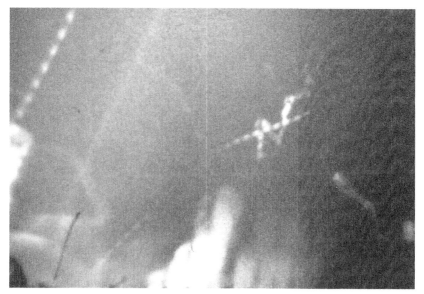

Using a computer to analyze the image, researcher
Lucy West was able to distinguish a "seated" figure
(pilot?) and a huge entity standing near.

A cropped version with greater contrast.

A sketch of the cropped version.

everywhere in the universe. Well, these Light Beings, the ones in this experience, were lesser angels; they are angelic and noble, and help us and help the world.

So I went with them, and we went straight up into the sky and far into space where they showed me a great vessel of some kind. There were stars all around it, and dotted here and there in the starry background were very bright stars that stood out like jewels of different colors. The brightest ones had rays of light shooting out from them. It was so beautiful and filled with color.

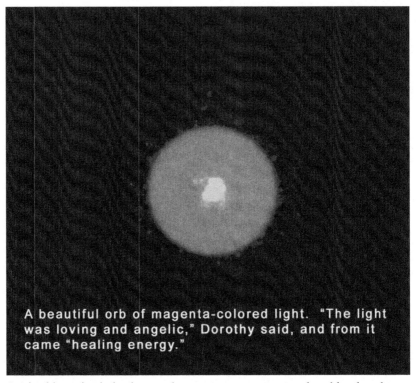

A beautiful orb of magenta-colored light. "The light was loving and angelic," Dorothy said, and from it came "healing energy."

Set in this majestic background was an enormous, round, gold-colored vessel that looked like a huge flying object. Whether it was such a thing I can t say, but it was immense. In the center at the top of it was a crown of gold. It was the most beautiful gold I'd ever seen, shimmering and lustrous. The Light Beings said to me, "That is for the Queen of Heaven." At that point they said they wanted to show me something more, and just then this magnificent golden vessel moved toward the stars and passed through the rays of

light emanating from them. As it did this, it made the most beautiful music I d ever heard. I can't describe it, but it was a soothing and wonderful music that seemed to radiate outward as the vessel passed through the rays of light.

As I watched this happening, the Light Beings said there was one more thing to show me. The next thing I knew, we were going down right into the sea. Strangely, it was bright enough to see down there, and we saw different types of fish and many other kinds of things that we can't see normally. It almost looked like there was a city under there. Some fish looked strange while others were familiar.

Afterward, they brought me back to my home and, in a burst of light, they were gone. This experience always stuck in my mind. Of course this was just one of many times the Light Beings took me up to the heavens, to show me things about the way the universe really is. This time I think the message was to show us that what we see in the world around us is not all there is. So much more exists everywhere in our universe that we can't know about while we're in physical form. We might catch glimpses of it here and there, but it's just beyond our grasp. If I were to explain it, I guess it would be like trying to go into another dimension using our physical bodies. Some dimensions are reachable only in spiritual form. The true self, the inner self, is limitless, eternal, and can travel anywhere. What I have on film is proof of this; you can see the light that comes from over there or up there, and so on. That's what the Light Beings are trying to show us in my films. That's why they've allowed me to film them, so others can witness visible proof that there's more to life than what this earth gives us.

CHAPTER 21 *Of Love And Light*

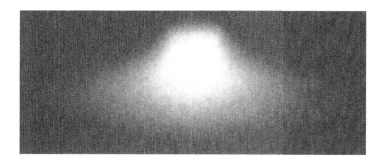

Many people have asked me to share what I've learned from all of this. I can understand it; why show me all these things if there's not some reason for it? Well, there's no simple answer that will satisfy everybody, even though over the years I've asked myself this question many times. I guess I can say that I've been shown a complete vision of reality, not only ours here on earth but that of other worlds and other realities or dimensions as well. The Light Beings have allowed me to take my pictures and get these things on film because it s a way to reach people without disturbing their lives. Of those people who see my films, some are moved, some are afraid, and some just put it out of their minds and forget about it. But it doesn't matter because the lights, in one way or another, touch every one of them. I'll try to explain what I've learned from my contact with the Light Beings and the many experiences they've brought to me over the years.

First, the Light Beings are in charge and aware of everything that goes on here on earth. They always have been. In fact, they've been with us since the beginning of the world. I can distinguish between them and ETs, for example, because there is a difference in the feeling they transmit. From the Light Beings comes a feeling of love, or grace. It's hard to explain, but I feel uplifted when they're near, almost taller in a way; there's always a clear message of some kind given to me. Let me give you an example. One night I woke up from a sound sleep and noticed a dim, blue glow on my bedroom ceiling. As I watched, something akin to hieroglyphics appeared within the

light. I said, "I don't understand those words." At that instant the writing disappeared and in its place came what looked like Latin. Again I said I didn't understand it, and in a flash the writing appeared in English. I asked why it just didn't start out with English, and I heard: "To show you an unbroken link to the past." The words on the ceiling read: "Watch for the true meaning of Remembrance." The following night, I don t know why, I got my camera ready. The Light Beings came and the light activity was magnificent. While I was filming, I felt the familiar sensation of being uplifted, a kind of inner elation, then I saw a staircase spiraling upward into the stars. It was as if my ceiling had disappeared and been replaced by this beautiful luminous staircase. It was absolutely breathtaking and serene. As this was happening, I heard very clearly, "This is Remembrance."

That was just one of many similar experiences I've had with the Light Beings where I came away with a feeling of blessedness. With ETs it's different, but remember, there are ETs of different quality who come from many different places, not just planets like Earth. Some Ets have a physical presence while some are made of energy. From some of them I've sensed compassion for human beings, but I don't feel uplifted by them. In their lowest forms, I can't relate deeply or communicate with them as a person would do with a friend. The lowest of them are indifferent, they can take us or leave us, and the feeling I've had toward them is the same, I can take them or leave them.

In a sense they're all extraterrestrials because they re not of this earth. A true ET, like those we hear about from UFO groups and see in movies, is a creature from space, in material form. Some look almost exactly like us, but others have different features. I've captured some of the little elf-looking Ets, the ones with big heads and wide-set eyes, many times and learned that their features depend on where they come from. Some of these have human-like heads with two eyes, two ears, a nose and mouth, and a body with two arms and two legs. They walk upright just as we do. There are so many different kinds of them from so many different places that I've come to understand that the universe is teeming with life.

The Light Beings I feel are angels. There are many levels of angels as well, and some work closely with people. These angelic Light Beings are pure spirit, and although they can take on a physical form if need be, they have no bodies. Occasionally, those that take physical form do so for a specific purpose and are what some call Guardian Angels. They all work together and they ve very loving between themselves. There are countless millions of these beings everywhere in the universe, each with a specific responsibility.

They watch all humans, and observe all the things that happen on Earth. There are other Light Beings that assist, or who can intervene as well. What they ve told me is very similar to what has been said in various sacred writings and traditions, also that there's truth to some of those ancient stories about angels.

The angels are beings created as light by God, but they have great independence and freedom, too. There are other life forms that look like angels, or that might be mistaken for angels, but really are just evolved life forms very much like humans. Some angel-like life forms are very evolved ETs who work with the Light Beings in a close way, closer than we humans can, and play a role in mankind s evolution by doing some physical work among us. Because of their highly evolved state, they're almost spiritual beings themselves, and they're aware of and follow the guidance of God and the work of the angels. We, too, have that potential.

People sometimes become confused when I talk about spaceships or UFOs in connection with the Light Beings, but these Beings use different images to make people more comfortable. They know the inner content of people, and can sense what a particular person will be able to accept and present themselves in that way, such as human form, or within a UFO or structure of some kind, or even as a religious figure. But no matter how they appear, their nature is unmistakable because of the intense love and benevolent kindness that comes from them.

These days what some people describe as Ufonauts, aliens, or extraterrestrials are similar to mankind. Some are spiritual and some are not; some are good, some bad. It all depends on where the ETs come from and what the state of evolution is of those places. Evolution is not just a physical thing but also a spiritual condition. All things grow and experience life in different forms on various levels. This is the message of all prophets and religions throughout our history. Both good and evil exist elsewhere in our universe. There are planets where people s inner or spiritual growth has advanced along with their great technical and material growth, where the people know how to live together in peace without hate; this is the key to their advancement.

I've always been asked the question why, if we're surrounded by all these life forms from advanced planets, they just don t land on earth and make us change our ways. Why don t they just take over? For one thing, the Light Beings won't let this happen. It's a law of God. We must first find our souls,

our spirit, our true nature and be allowed to evolve on our own without interruption from anyone. How long we will be granted this freedom, I don't think anybody can say. We've been given chance after chance after chance, the world goes on, and still we don't seem to be learning our lessons.

It's important to remember that most of the ETs I've seen and filmed look like us. They come from various places and I wouldn t call them good, and I wouldn t call them bad. They simply have interests here and just go about doing things with a sharp focus. They're not particularly concerned about us unless we interrupt their activities. People find that hostile, I guess, because many people resent not being included or informed. It's sort of funny to me; we can't even live together in harmony, yet we expect ETs to treat us as equals. If we think about it for a moment, how does it look to an ET coming here from some distant world? They don't just see little pockets of devout and kindly spiritual people here and there, they see the whole world at once. Even though many of us are civilized and treat others in a kindly way, even at this moment there are murders, wars, and acts of inhumanity everywhere. It doesn't paint a very pretty picture of the state of things here on earth. At times, it s hard to tell the difference between animals and people. So it s no wonder that some Ets might consider people to be little more than fearful animals, and deal with them in that way.

One message I've gotten from all of them, even the lower-level ones, is that they harbor a deep dislike, as well as a concern, for the chaos here on earth. While they acknowledge our technology, they seem more concerned with our behavior; after all, the ability to turn a stone into a pocket-watch, so to speak, is of little importance if the way people behave is destructive. Spiritually, the people of earth seem to go nowhere, not up, not down, as if they re stuck.

They're also concerned about being attacked. What I've been told is that people have attacked them in the air and on the ground many times. I sensed a deep feeling of fear when this was communicated to me. I realized how the ETs must feel, knowing that any minute, if they land here and try to contact us in any major way, people would try to disable them. This tendency to violence doesn't bode well for earth. I mean, why would the people of other planets want any contact with us or welcome us to visit them? They know there are some good people here, but the good people have little influence and are outnumbered by the bad ones.

I think it's very important to remember that we live in a world where everybody's protecting something. People protect their jobs, their reputations, their money, and their possessions. Leaders protect their power, and governments protect their countries. All this self-interest leads to conflict and sometimes misery, death, even war. Over the years I've been allowed to see the future, and have foreseen the death of Gandhi, the deaths of Sadat, Francois Mitterrand, Princess Diana, and the Shah of Iran. I asked the Light Beings why I knew about this ahead of time, and the reason was simple. It's the leaders that bear the greatest responsibility. They are the ones people follow, the ones people pay attention to and rely on to govern them. People are, in a way, like sheep that can be led to the slaughter by an evil leader. So it's the leaders that the Light Beings are very concerned with. The world today, even with all it's advancement, is still a world of leaders and governments who can either bring us peace or bring us misery, and there's not very much any of us as individuals can do about it. The Light Beings and all the higher powers know this.

It's easy to think, well then, why don't these higher powers just put a stop to it or step in and make changes. It's because there's a law, a rule not to force anything on us; not to kill or even hurt human beings. From my own experiences with them, I can tell you that the stories about ETs injuring or killing people are fiction. They won't, they can't kill; it's a law of the universe. We're the ones disobeying this law. That's why our world is considered one of the lowest in existence in terms of moral and social advancement. I think this is at the root of all the great religions and spiritual movements in the world, and in the messages of saintly people who've tried to bring the importance of purification and spirituality to us. The thing to remember is that whether or not we decide to accept spiritual truths has always been a choice we could make. Nothing has ever been forced on us.

Some say that ETs are hostile and abduct people for horrible experiments, usually of a sexual nature. This is completely incomprehensible to me, based on what I've learned over my many years of filming. Actually, I think it's our doing, our tendency to violence and perversion that we're projecting on the ETs. People on earth aren't fully human. Even the animals act better or more civilized in some ways than people do.

ETs acknowledge and recognize God just as many people on earth do. It's not God as a person, or a personality, but as the central force or wellspring, a power that gave rise to everything that is. Once, when I was filming one group of them, I asked about this. They said they were more aware of God

than we are, because they're closer to God than we are. In this particular case, I was in contact with a higher order of ETs, but even the lower ones acknowledge God, and know the difference between right and wrong, and recognize that fact that suffering comes from our own actions. That should say something about where we stand in the order of things.

I know there are some people who liken ETs to demons or robots or some other frightening things that have no feeling of friendliness to humans. But I know that even among the lowest of the Ets, there's an awareness of a universal force, a guiding Principle. They don t seem to have a very deep understanding, but they do acknowledge this principle. This is the same as it is with many people on earth who have no active communion with God in their lives. They experience no process of change or active growth in themselves that comes from submission to God and His guidance, but they realize that something higher is behind everything.

Occasionally, because there have been so many UFOs sightings over the years, somebody will ask if I know why the ETs are coming here. Actually, there are all sorts of them coming here, and it's primarily to help us, not to hinder us. We seem to be so self-destructive. They know the struggle mankind is going through, man with his impulses and weaknesses, and that even the best of intentions somehow go awry. Man is like a twig in the wind, bending this way and that, according to the forces pushing him. They see man as a puppet yielding to the negative impulses within himself. Even man's senses are limited. People have eyes but can't see, ears but can't hear, and even when guidance comes loud and clear, they act as if they must deliberate on whether or not to follow that guidance. How people see my films is an example. Many people have seen my pictures and feel no impulse to pursue the light within, to question their values, or to even stop and think about what it means. I had one scientist fall asleep while watching my films. He woke with start, rubbed his eyes, and said he thought it was dust on the lens. Other learned people guess at what my films show, but it s always a guess that leaves them comfortable with whatever they believe. We don't try to connect to our inner beings; instead, we rely on our own cleverness. Rather than ask, "What can I learn from this," many people already have an opinion and walk away satisfied.

The Light Beings, like some high order ETs, want to help us. But they can only help in subtle ways because human beings have to pull themselves up by their own merits. We've got to want to do it ourselves. It's no good if somebody does it for us; there's no permanent growth in that. I don't know

why this is such a hard thing for some people to understand. To learn from our mistakes and the mistakes of our ancestors, to experience and grow and to reach the eternal is really the reason we exist. Otherwise there would be no purpose to suffering in this world of uncertainty. There would be no reason for the world to exist.

Among other things, the role of the Light Beings is to keep us from committing suicide. When people began experimenting with nature, things started to get dangerous. Take the atomic bomb, for instance. I know that sounds corny because we've seen this theme in movies, but a lot of people laugh at the idea that the bomb brought UFOs to earth. But silly-sounding or not, it really happened. Even the men who invented the bomb weren't sure if they were about to destroy the world. What people don't realize, and this was something given to me many years ago, nuclear experiments were extremely dangerous, not just to the people who were killed by the experiments and by the bombs, but to the subtle energies that bind the dimensions. This posed a real danger to other life forms as well. From what I gather, there is a dimension quite close to ours, and the membrane that divides the two is fragile. When we tamper with nature, and it has gotten worse in recent years, by using atom bombs, or experimenting with strange chemicals that pollute our atmosphere, we weaken this membrane. If there's a break, there will be chaos on a huge scale because both the earth and its nearest dimension will be changed. The Light Beings and the ETs have been concerned about this for along time. This is why some of the ETs have been coming here.

Man has reached a level of technology that is quite familiar to the Light Beings. We've not only fooled around with nature, but we're trying to alter, and even create life by means of transplants, cloning, and other kinds of genetic experiments. Without a spiritual life, without spiritual awareness and respect for what was created, for who we really are as whole beings, the results of these things can be quite devastating to the future of mankind.

ETs have been aware of what we do here since the beginning of our history. Space and time don t exist for them, or the the Light Beings either, since none of them are of this earth. The ETs from planets out there don't travel through space; they just pop in and pop out instantly. Of course all of this is from my own experience, or from what I've learned from the Light Beings. Except for my films, I know of no way to prove any of the communications I've had. They've shown me many things, some I understand and some I don't understand. For example, they've shown me that there are many ETs that can enter our space, but this seems to depend somewhat on timing. I

don't have a technical mind, so it's hard for me to explain. But they wait until there's an alignment of some kind, or when corridors or thresholds are lined up, then they enter and arrive here. But they don't have a long time here to accomplish what they need to and leave again. If they miss it, they have to wait until the next alignment. They can get stranded here for a while. I don't know whether people can go through the corridors; it hasn't happened to me, at least I don't think so, not physically. I've gone through by psychic means, or by means of my inner-self, which is even harder to explain, so I won't even try here. They can also travel through time, something I've not understood at all, but they have no trouble doing it.

I've never seen so much interest in UFOs as I have in the past fifteen years. It seems bizarre stories, theories, and claims about them have turned up a lot from about the mid-1980s through the 1990s...crashed UFOs, government cover-ups, cattle mutilations and abductions, all sorts of outlandish things. Well, these things are very exciting, I guess, but in my experience I've seen nothing that would lead me to be concerned about any of it. There are some ETs that could do these things, of course, because I know they've done biological experiments and such. These are the ones who are much like us, and what they do is a lot like our own experiments. I know that some of them use androids, and I even have these on film. They use these artificial creatures because they don't want to come down here directly and confront people, don t want to fight, hurt, or kill them. If people try to shoot or capture the android, it's not so bad, because there wouldn't be the need for a violent response. It's one thing to lose an artificial being; it's quite another if the ETs themselves are attacked by people because then they'd have to react, and people could get injured or killed. We have no hesitation when it comes to harming or destroying each other, regardless of the reasons, but the ETs won't do it.

The little bigheaded big-eyed creatures, the ones some people now call the Grays, are androids. They all look identical to one another with almost nothing to tell them apart, as if they were stamped from the same mold. They don t experience emotion and they don t veer from their purpose. It's this machine-like focus that troubles some people, because any encounter with these androids is very one-sided. They do what they're supposed to do without any variation at all.

The high entities don't do such things. I've asked about abductions many times, especially since the subject was turning up quite a bit in the media. Basically, what I was told was that sometimes people ask, or want, to be

taken onboard a UFO, and they will be. This desire to be taken on a ride or to see the inside of a UFO and the ETs piloting them is more prevalent than we can imagine, and those who are taken onboard are helped in some way. In my opinion, based on my experiences, only a small number of those who say they were traumatized actually were in some way, maybe because they were terribly frightened and hysterical. The rest of them, people who say they were raped or injured or made pregnant, are troubled people who are deluding themselves. I've heard stories where some writers say they think millions of people have been abducted and so on, and I find that hard to believe. I don't know, of course, because there are many ETs coming here, and they have been for centuries, so anything's possible. But I think the situation is being exaggerated.

Although, as I've said before, there are some ETs that are capable of such things, I've never had any trouble with them. I really believe that in most cases it has something to do with the kind of person involved. When a person is filled with gruesome imaginings or fear, or is disturbed in some way, or feels a strong need to be in control, anything he experiences that is unusual or unexpected will be terrible for him. I think if we dig into the backgrounds of these people who claim such horrifying experiences, we'd find they're basically fearful, anxious, negative people. I learned early on in my experiences that we are where we dwell in our minds and feelings. If we think ETs are horrible alien invaders with evil motives, like we see so much of in the movies and television and books, then we'll attach these fears to any real experience we might have, or worse, we might actually meet up with what we fear. A friend of mine once told me that if we keep looking for the Devil behind every tree, we're liable to find him there. I agree with that.

I've talked with many UFO researchers over the years, and they often wonder if my sightings, the ones outdoors in the sky, are always just of small lights in the distance at night. Of course the answer is no; I have many films of daylight objects, including a recent one from inside a UFO as it lands on a highway. From this vantage point, in the distance there's some kind of giant man-like creature running along on the ground parallel to the UFO. People are quite astounded by this footage because it's all there as plain as day. Anyway, no, I've seen objects in the daytime as well as night. Night or day, I've filmed objects of all sizes, too. Some have been immense in size. I filmed one that appears to be round, but if you look at it carefully, on each side of the craft there's a separation that allows it to change shape. Sometimes it's round, sometimes it's elongated and appears cigar-shaped. Another time I filmed one that was so huge that only a small portion of a lighted outer

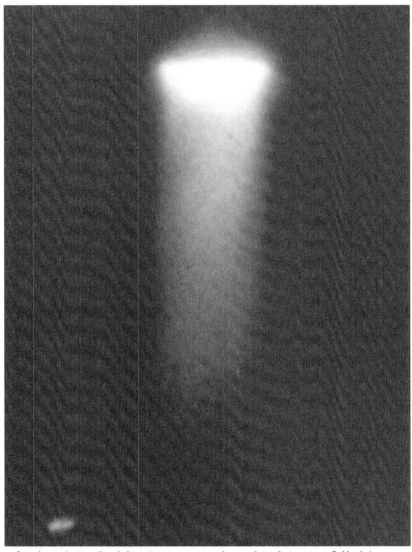

A structured object appeared and a beam of light projected from below. A smaller object (bottom left) descended the beam and moved toward Dorothy's position. The smaller object flew back and forth across the sky several times before ascending the light beam and re-entering the larger object.

edge can be seen in the frame. Another was very big and saucer-shaped with a beam shown emanating from its underside. A small red ball of light came down out of the beam and flew about here and there. I have film of this happening, and the still photographs I made of this piece of footage are favorites with people who've come to visit with me.

I've got quite a lot of film now and many pictures of beings, craft, landscapes from other dimensions, and all sorts of things. It's interesting that almost as many times as I'm asked about my personal encounters and films, I'm asked if there's any advice I have for people on how to contact the Light Beings. I can't tell you how often someone has said, "Oh, Dorothy, is there any way I can learn to do this?" Or, "Is this a gift, something you're born with, or can anyone do it?"

Well, the Light Beings are waiting for man to raise his consciousness. This means to become truly conscious of something higher than man himself, not just with the brain or the intelligence, because a lot of people say they believe in this and that, but from within the deeper part of our nature. What I experience is not of the brain, or the intelligence; it doesn't depend on how much a person knows or how smart he is or how logical he is. When the Light Beings worked on my eyes so I could see them closer, this wasn't anything medical or anything I could simply do by thinking about it, this was done by an energy or spiritual grace that could reach the power of my sight. In the higher realms we don't use our physical eyeballs; instead, we use the powers of sight, hearing, and speech. This is what makes up our souls; this is how we communicate and experience things outside our physical bodies. In the hereafter we don't have any of the physical senses, but we have the power of the senses. This is what we must come in contact with and allow to develop while we're alive, and this all depends on how spiritually alive we are.

We're coming to a time in the world now when man must make a decision. We've been long enough in an unchanged condition. All we need to do is look around us. Machines surround us; we're surrounded by technology, by information, but man's still very much as he was centuries ago. It's as if we haven't learned anything. Oh I know there are people who want to see the beauty in the world, who want to believe that good is overcoming evil. But this isn't reality; this isn't the way it actually is. In reality the world is filled with bloodshed, jealousy, disease, arrogance, and divided nations and people.

There are many dimensions. The Light Beings can move among them all. If someone wants to know the Light Beings, or experience them, he needs to start at the beginning by raising his thoughts. To the very basic person this means start by becoming more spiritual in outlook, not necessarily religious, but spiritual in the sense of how we feel, think, and act in our everyday lives. Try to stop thinking about the world and the people in it as just so much material stuff. Try to behave like a high, loving creature. Try to be less judgmental, competitive, and angry. Try to be more forgiving and compassionate, and try to develop or nurture the psychic ability that we all have in us to some degree. Sometimes small changes such as these can cause a rise in the frequency or quality of the energy we send out. Feeling a sense of submission to God, a kind of giving up in order to receive; thinking of good things, kind things, healing things more often than not. For some people, just making little alterations to their usual daily habits will raise their feelings enough to contact the Light Beings. For others it may take more, like divine help to get in there and purify the spirit. For these people I don't have any advice, because this is up to God. They have to find God in their own way and then allow God's grace to change them inside.

What people need to realize is that everywhere in the universe there's a single understanding of God, a supreme Life Force. The Light Beings and all the higher life forms agree on the nature and presence of the one God. There are no divided religions, cults, or groups, each competing to get into Heaven. No, this isn't the way it is, and it isn't supposed to be that way on earth. But the Light Beings, who are, in a way, deputies of God because they are so close to God, understand that spiritual evolution must begin with each person individually. The higher beings have a problem with the negative vibrations that come from the earth. People are functioning at such a low level most of the time that the higher beings can't, or won't, get near them. It's like being in a stink hole to them. If we approach something that smells bad, we avoid it, or we find it difficult to be near. I'm not saying they actually smell something, but it's similar. What we do and think, and how we feel generates outward like rays of light, and if those rays of light are tainted, then we can't fit in to the higher worlds. For instance, something I learned early on was the Light Beings love little children, and they smile on people who love and care for children. It's no wonder, really, because children are clean and innocent in their feelings. There may be a lesson in that for us, that maybe we have to be like children in our feelings and thoughts. All the higher powers are disgusted by the neglect and misery children suffer in our world.

The Light Beings don't expect us to raise ourselves by our own efforts beyond what we are capable of. Many people can't raise themselves very far, not really, no matter how hard they try because the low forces that produce the impulses in them are just too strong. Sometimes, though, just holding a positive thought, a high thought, a loving and unselfish thought can be enough for the Light Beings to show themselves, maybe dimly and at a distance, but show themselves nonetheless. Many people have told me that they've seen high-flying lights, or bright flashes off in the distant night sky, or dancing lights here and there, and these could very well have been the Light Beings. If these people knew how to surrender, how to let God take over, then maybe the lights would have come nearer and been brighter.

For me, it started when I was quite young. I've always been a spirtual sort of person and, as a child, I had many psychic and unusual experiences. I think this has always been an influence in my life. I can't explain it, but I've always been able to detect subtle things, and I've always felt a deep love of God. Maybe this is why people who are facing tragedy or death will sometimes meet the Light Beings, seeing them as angels or as a loving bright light. At those times they think of God, or they pray, or they give up in surrender to a higher power, raising themselves, even if only for a moment.

Man is very arrogant. He thinks he can do anything with his intellect and skills, even tamper with life itself. How many teachers, philosophers, or writers talk of surrender to God? Not very many, but all of them talk about how we can control our lives, manipulate this and that, bring happiness to ourselves through thinking exercises and so on. The truth is, as I've come to understand it over the years, when people try to do for themselves, as we're taught to do by our parents and in school, we drift further away from the Light Beings. At those times we're left to handle everything for ourselves. When we surrender, and often we don't do this unless we're forced to by things we have no control over, like death or overwhelming difficulties, we elevate our thoughts and feelings, and sometimes we meet the Light Beings. It doesn't have to, and shouldn't, be this way. People shouldn't wait until things are so awful, or until they're facing death, to experience the Light. If it's like that, then they haven't learned anything about life; they haven't learned that being here on the earth isn't about just doing whatever they want and then dying.

Just remember this, the Light Beings are made of love and light. Because God loves mankind, they love mankind. It's because of this great love that the world has been allowed to go on despite all the horror and agony that

mankind has inflicted on itself. If God wished, the earth could be made to disappear right now, but God's love and mercy toward us has kept us alive. If anyone doubts this, if anyone thinks I'm being too spiritual, then I ask them to look at my pictures. What do they think the images show? Some people question my explanations, but even when they do, they can't come up with another explanation. Whether anyone agrees with me or not doesn't matter because I know what my pictures show; I know what the Light Beings are telling us; I know because I've been there, done that, as the saying goes.

Finally, the Light Beings told me that man has had the truth for centuries but has not heeded it. We've been given a lot of second chances. In a spiritual sense only a small number of humans have held this planet together, small in comparison to the millions who've contributed to its downfall. Counted among the good are the prophets, the saints, and the enlightened ones from all of the world's cultures. The Ets, the Light Beings, really have no interest in the earth for its own sake. They're interested in the people and what will happen to them ultimately. So really there's still hope for everybody. The light people see in my films, the bright flashes, for instance, these are showers of grace extended to earth and made visible by my camera so that others can see. But the light of this grace is there, whether a person can actually see it or not, and it washes over all of us all the time. Now what will people do with what I've shown them in my films? Will they see this as proof of something beyond, a reason to look up, to reach higher, or will they shrug it off and forget about it? The decision may well mean the difference between a world of light and a world of darkness.

CHAPTER 22 *Epilogue*

This book was never meant to be the definitive exposition on the life and times of Dorothy Izatt. The dramatic and often terrifying events of Dorothy's struggle to survive during World War II would in itself fill the pages of a book. Add to that a lifetime of supernatural experiences on a scale large enough to occupy several lifetimes, and it's obvious that no single effort of modest length would be adequate to tell the whole story. At the time of this writing Dorothy Izatt is a spry 80-year-old and continues unabated with her photography. After her husband, Duncan, passed away in 1989, Dorothy found great comfort in the company of her beloved Light Beings. Though she was alone - her adult children having long since left home to pursue lives of their own - she never once entertained the thought of giving up "the work," which, to this day, is unlike any other in the annals of the paranormal.

In early June of 2000, following almost six years of contact with Dorothy via telephone and mail, I took advantage of a break in my usual topsy-turvy schedule and started planning a July road trip to visit her at her home in Richmond, BC. In a fitting prologue to what was to come, mysterious lights began showing up nightly in the skies above my house situated in the foot-hills of the San Gabriel Mountains in Southern California. Often, usually late, a single bright light appeared out of nowhere and glowed brilliantly like a great diamond for several minutes. At other times a silent small round object with a silver-white strobe circled overhead and answered to the blinks of my flashlight. Shortly before our departure, an enormous triangle-shaped

object with bright lights on its three corners hovered over our heads as we stood in my front yard. My family and I experienced these sightings together and even managed to videotape some of the eerily beautiful lights. There was no doubt in our minds that the unexpected light show had everything to do with our upcoming visit with Dorothy.

On July 16 my wife Luzita and I, our 11-year-old son Herbert, artist Lucy West, and long-time friend Samara Osborne sat elbow-to-elbow amid a ton of luggage stuffed from floor to ceiling in our minivan as we set out on the 1300-mile drive to Canada. The time and miles passed quickly, and we arrived in Vancouver on the afternoon of the 18th and found a hotel some five miles north of Richmond. A few hours later we were standing at Dorothy's front door being greeted by this small bundle of a woman. Her hair now a silver-white, her clear deep-set eyes glimmered with the single penetrating and intangible spiritual identity that filtered through so often in my past conversations with her. Dorothy Izatt is indeed a lovely woman, very tiny in stature, and of uncommon good nature. She never has a critical word to say about anyone, and her humility and modesty belie someone of such extraordinary experience and knowledge.

When we arrived, Dorothy's warmth and graciousness made us all feel instantly at ease. Her little apartment was spotlessly clean and carefully decorated with knickknacks and cherished keepsakes, but behind the external ordinariness of the rooms there was something more - a feathery wisp of energy or undercurrent that was instantly noticeable. As we walked along the narrow hallway from the tiny foyer to the living room, I found myself reflecting on the composite of wonders that had been Dorothy's life in this place. Over the years I'd seen a dozen or more of her films taken from inside the apartment, each more striking than the last, and each giving graphic testimony to a power that can transform the natural to the supernatural in a burst of light.

For a long moment I stood at the end of the hallway absorbed in thought until voices brought me back to finish my hellos. After an interval of settling in and many long minutes of cheerful talk, Dorothy began showing us some of her latest films, including one of a luminous figure of woman dressed in soft white gossamers and carrying a small child into a beam of light. As we viewed the remarkable image, we were struck by the sudden sensation of "heat radiating through our feet and hands. I was the first to remove my shoes; the others followed in close succession. When we described what we were feeling to Dorothy, she said, "They must be here." Almost precisely at

Dorothy Izatt in the year 2000

"Tending to the children." An angelic being seems to be guiding children into a corridor of light. This image appeared in a bright burst of blue-white light. It was shown to the author in its "moving" form during his June 2000 visit with Dorothy Izatt.

By using a computer to carefully analyze the shadings and contrasts of the above photograph, researcher/ graphics artist, Lucy West produced this rendering.

that moment a light appeared in the center of the room and shot straight up through the ceiling. We all sat there looking at one another in stunned disbelief. Dorothy responded with a quiet laugh, "Yes, they're here, and they must be happy with the company." After a brief clamor of excitement and moaning over the unhappy fact that our cameras were still buried deep in our duffle bags at the hotel, we continued watching the films and within an hour the heat sensation subsided and was gone. The rest of the evening passed rapidly and there was little doubt among us that if ever there was a place for magic to happen, for strange beings and denizens of other worlds to appear, it would be in this improbable place with our diminutive lady of light.

We drove back to the hotel later that night, and just as we got out of the car, my son cried out, "Dad, look up there!" A huge light was taking shape directly overhead. Silent, icy blue-white in color, it moved slowly and then stopped just below the cloud cover. Looking very much like the big bright light we d seen at home, it hovered silently and blazed for the better part of a minute before blinking out. The parking lot was quiet and empty of people, except for two men who were walking a short distance from us and toward the hotel's lobby door. Apparently the men, wrapped up in their own conversation, didn't see the light which to us seemed too obvious to miss.

The next evening we visited Dorothy again, but this time we brought our cameras. After about an hour, Dorothy suddenly squared her shoulders and for a moment seemed to be sensing a presence. "I think you should go out on the terrace now," she said. "They might be coming for a visit." The group of us scurried out to the little porch that overlooked a narrow grass-covered strip of ground behind the apartment. A tiny wedge of gray sky was visible between an overhang and the trees across the way. We craned out necks for several minutes as the clouds slowly cleared away and suddenly Lucy West yelled, "There, look there!" At that moment the familiar bright light snapped on and scintillated for several seconds before it again winked out. To its left, or west, came the little object with its silvery strobe. It circled once rapidly, left toward the south, and disappeared. It all happened so fast that we totally forgot about our cameras. We talked among ourselves for a few minutes about the importance of keeping our wits when suddenly, from out of nowhere, an enormous, silent triangular-shaped object passed overhead at a slight angle, squarely in our line of sight. This time, with cameras clicking away, we managed to capture the big object on film, as well as numerous smaller lights scurrying in every direction. Afterward, Dorothy, who had been standing behind us on the porch, giggled delightedly. I think

not because there had been so much to see all at once, but mostly because of the happy expressions on our faces and giddy excitement in our voices.

Altogether we spent four unforgettable days with Dorothy Izatt, talking over her experiences, watching wisps of energy dart about the rooms, and removing our shoes at intervals to cool our feet. The films were marvelous, and we couldn't help but notice that quick green flashes of light preceded many of the images and scenes, those being the opening and closing of doorways, Dorothy said. As we gave our farewells on the last day, Dorothy reminded us to, "Keep watching; this is just the beginning." Prophetic words, for on the way home we spotted a bright flash of green light followed by the familiar little strobe blinking here and there at intervals as we made our way down the long stretch of highway back to California. At this point I couldn't get the smile off my face. Not only had our visit been everything I expected but it had also proven an important point...namely, that it's possible for observers to participate in Dorothy's ongoing experiences and filming, provided they're willing to take the time to do it. The problem is the prevailing attitude of researchers who have shown no motivation to set up a full-scale project to investigate the "Izatt Phenomenon" in order to establish its relevance and importance.

To date, I've spent more than thirty-five years investigating extraordinary claims and reports of unexplained phenomena. I've met many remarkable people with wonderful stories to tell, but Dorothy Izatt has succeeded in doing what no one else has done. In my opinion, and I can think of no better analogy, she has given us the "Rosetta stone" of the paranormal. Her films are more than pretty pictures and may actually represent a language that can provide the key to deciphering many of the world's most baffling and persistent mysteries. The significance is in the apparent linkage between seemingly unrelated phenomena. When Dorothy's communications and perceptions are combined with corroborative images on film, various dissimilar events are clearly bound together.

Knowing Dorothy as I do, and after working with her for nearly eight years, I'm convinced there s no single explanation for what she has captured on film. Nobody can say with provable certainty that what we see in her films is spirit photography, channeling, or some weird form of mind projection induced by exotic brain chemicals or the like, even though all of these "explanations" have been enthusiastically tendered over the years. If the film images were produced in the mind, for instance, and somehow magically projected onto the film, then how do we explain my experiences both

near and away from Dorothy, and the testimony of others who've witnessed various phenomena while in Dorothy's presence or during her filming episodes? The "Light Beings" aren't merely "weird lights that nobody can explain," as one nonplussed enthusiast remarked, and Dorothy isn't just another so-called "channeler" or "UFO contactee." Her encounters embrace elements of multiple phenomena, including structured objects, physical transport, time travel, intelligent and interactive entities and, in Dorothy's words, "beings of light . It's precisely this mixed and varied blend of activity that ought to alert researchers that something of singular importance is taking place. The images don't exist merely to entertain us or to give us more fuel for random speculation about the nature of the cosmos. The pattern and consistency are indicative of an intelligence seeking to express itself, and whether expert or layman, Dorothy's descriptions of what she sees and interprets, inwardly and outwardly, should be considered a thousand times more reliable because nearly every event has been recorded on film. The corroboration is there; it's visual, consistent, distinct, and unmistakable.

Be that as it may, since the beginning of her filming in 1974, the reaction from researchers and people in positions of influence has been surprisingly lukewarm. To me this is a great puzzle. With a few notable exceptions in the years immediately following Dorothy's first attempts at filming, not one distinguished researcher of the current batch has taken the time to study Dorothy's films, much less seize the opportunity to study her work in her presence. In the mid-90s, on Dorothy's behalf, I sent edited samples of her footage to several ultra wealthy men who claimed publicly to be interested in UFOs and related phenomena. One refused comment, preferring instead to sink his money in a cow farm where people had reportedly seen UFOs. The other replied with a rather convoluted tract on his opinion of the fate of the human species. Neither man affirmed the unique fact that one person was responsible for hundreds of reels of live-action movie film, nor - when all the circumstances were taken into account - that one person presented a rare opportunity for an observer to experience the subject of interest first-hand.

Dorothy Izatt is without peer anywhere on record in the world, even when compared to today's tabloid media with its endless loops of bizarre video footage from various places and people. Aside from the fact that electronically simulated video images aren't as yielding to analysis as the images in film photography, the obvious difference is that the footage derives from multiple sources. When this hodgepodge is lumped together and seen constantly on television and in movies, etc., the combined effect is to overshadow the significance of any single individual or individual instance. To

me this is tantamount to missing the trees for the forest. With Dorothy we have a credible, trustworthy, prolific source in one location - or in any location anywhere she chooses - willing to demonstrate the process for an observer. One would think researchers, scientists, or anybody with a yen to experience something higher would flock to Dorothy's door just find out how she does it or, at the very least, to see what she sees. But not so. I find this lack of response nearly as enigmatic as the images in Dorothy's films. As a researcher I can see no practical logic in the apathy that invariably beclouds the minds of my colleagues anytime the "Izatt Phenomenon" is mentioned. Research mandates observation, which means a researcher - if he's to call himself that - must follow a lead wherever it takes him, even if it entails leaping headlong into uncharted territory. If I were to speculate, it's possible the "experts" are intimidated by the range and depth of Dorothy's work. Perhaps in some way it threatens to force them into a confrontation with their own cherished beliefs and prejudices.

Throughout the 1990s I made attempts to introduce Dorothy's films and the circumstances surrounding their making to well-known UFO experts, noted parapsychologists, psychics, various sympathetic scientists and eminent writers known for their interest in the paranormal. Despite their much-touted collective insight and "forward thinking," they just "didn't get it," to put it into today's parlance. On the other hand, while all of them were quite eager to offer an opinion, none was ready to commit resources or expertise, or to show a grain of willingness to pursue further inquiry. One popular writer, whose book about UFOs was on the best-seller list for many weeks, opined with confidence, "I know what those lights are, they're lost human souls." His comment made as much sense as that of an East Indian yogi of the 1950s who said that all unexplained lights seen in the sky at night were migrating astral bodies of mentally ill people! Another man, a scientist with books published on parapsychology and related subjects, said: "Very interesting, has anybody ruled out the aurora borealis?" Then he launched into a harangue on his latest pet project. I could cite many more examples of similar half-baked reactions, but the point is there seems to be a perception or recognition problem, an inability or unwillingness to take notice and admit that what Dorothy is doing is totally different from anything else. Whatever the cause of the impediment, whether mental, emotional, egoistic - or all three - there's some kind of peculiar psychology at work in the resistance to Dorothy Izatt that no doubt would make an interesting study in itself.

It's hard to imagine that in twenty years not one professed devotee, expert or otherwise, has acted on the uniqueness of Dorothy's vast collection of films.

This is not to say that people haven't shown an interest. Certainly in the early years there was a flurry of excitement among local enthusiasts, but those with a measure of expertise were for the most part students of the arcane, hungry for confirmation of their own special interests and beliefs. By far the greater majority were ordinary folk with little or no qualifications and little if anything to offer by way of assistance to Dorothy. Today even the few scientists still living who worked to some extent with Dorothy long ago have limited or curtailed their involvement for various reasons. This is particularly worrisome because, to date, there has been no effort to archive or catalogue the films, and presently there's no plan to do so. Despite my efforts to elicit interest by arranging for Dorothy's appearance on popular television shows of the 1990s, and my numerous appeals to individuals, independent researchers, and organized research groups, no offers have been forthcoming, and prospects seem quite dim. With more than 550 reels of film currently in the collection, the task is much too burdensome for an 80-year-old woman to do alone. Any such project would take time and money, and must be done with Dorothy's close collaboration to assure accuracy of the documentation. The problem is, the proverbial clock is ticking and if anything is to be done, it must be done relatively soon. When Dorothy leaves us, there's a slim chance her heirs will donate the films to someone or some organization that will make them available to the public. But much of the true meaning and message of Dorothy's photography relies on her personal descriptions. However beautiful and mysterious the moving pictures might be in themselves, without an accurate and complete record of Dorothy's insight into the significance of the images, the collection will be only half preserved.

It's my hope the rather dismal outlook will improve by the time this book reaches the public, or perhaps by the good will of some casual reader of this manuscript. Unfortunately, if the indolence of the past is any indication, though the medium may be preserved, there's a real and disturbing possibility the irreplaceable insights of Dorothy Wilkinson-Izatt will be lost forever.

Printed in Great Britain
by Amazon

61757046R00088